IMAGES
of Rail

RAILS AROUND
WESTCHESTER
COUNTY

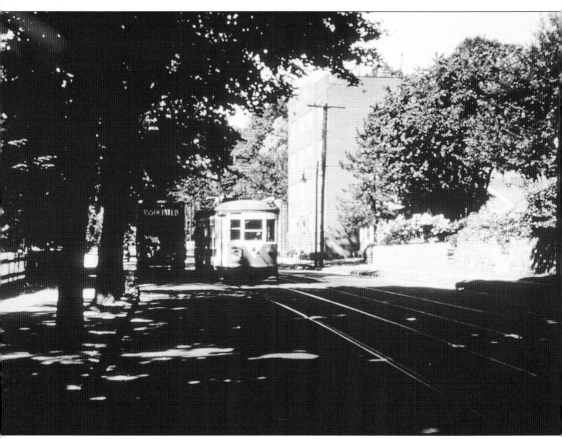

On Warburton Avenue, near the Yonkers-Hasting line, the Third Avenue Railway System operated much of southern Westchester's streetcar lines until 1952. With the New York, Westchester & Boston's purely electric railroad and the New York Central Railroad's bucolic Putnam Division, the county had a diverse rail history. (Courtesy of Otto M. Vondrak.)

ON THE COVER: Croton-Harmon is shown in the late 1940s in the transition years of steam's twilight as an eastbound New York train arrives to replace its steam power with electric. Diesel power would soon be taking over, changing the way railroads operate. Harmon was and is the county's largest rail facility, built to maintain locomotives and the several hundred commuter coaches. It was also busy with engine swaps, a roundhouse, and local trains, plus mainliners. (Courtesy of the New York Central System Historical Society.)

IMAGES
of Rail

RAILS AROUND
WESTCHESTER
COUNTY

Kent W. Patterson

ARCADIA
PUBLISHING

Published by Arcadia Publishing
Charleston, South Carolina

Printed in the United States of America

Library of Congress Control Number: 2018957204

For all general information, please contact Arcadia Publishing:
Telephone 843-853-2070
Fax 843-853-0044
E-mail sales@arcadiapublishing.com
For customer service and orders:
Toll-Free 1-888-313-2665

Visit us on the Internet at www.arcadiapublishing.com

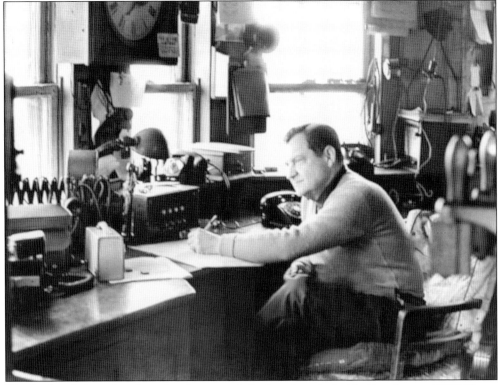

This book is dedicated to the railroaders, especially those I worked with. Seen here at "OW" Tower at Tarrytown is telegrapher operator Jack Springer, photographed by his son John, who became an Amtrak locomotive engineer. Railroad towers were often called interlockings, and controlled traffic safely. OW Tower routed local trains, but its main task was assisting in expediting auto parts to the General Motors North Tarrytown plant and placing cars to and from westbound trains. (Photograph by John Springer.)

CONTENTS

ACKNOWLEDGMENTS

This book is a pictorial overview of railroads in Westchester County, with some pertinent references to railroads outside Westchester but related to the county's rail systems. Rather than writing a detailed, focused book on one specific aspect of Westchester's railroads, this effort strives to offer an eclectic view of the varied aspects of local railroading for the Westchester commuter, rail user, or just the curious.

Many helped this project. Grateful thanks to contributors, authors, historians, historical societies, photographers, an artist, and a cartographer. These individuals are gratefully credited and/or mentioned throughout the book. The bibliography on page 127 notes numerous books relied upon and recommended as additional reading.

Additional thanks go to the Pleasantville Public Library, Richard Stoving, Joe Epperson, Sheldon Lustig, J.W. Swanberg, John Tolley, Otto M. Vondrak, Robert A. Bang, Barbara Davis, Pete Hansen, Walter Brett, Danny O'Connell, Eugene Croft, Pat McMahon, Joe Perrotti, Joe Zacconi, Ray Terwiiliger, Caroline Anderson, Susan Thompson, Cynthia Curtis, Danbury Railroad Musuem, Naugatuck Railroad, Catskill Mountain Railroad, Delaware & Ulster Railroad, and New York Central System Historical Society. Paul Freeman provided help for this volume as well as my *Westchester County Airport* book.

INTRODUCTION

Before the railroads or the Europeans, Westchester County was a wilderness, sparsely inhabited by its original peoples. Manhattan Island was a longtime home to the Canarsee branch of Lenape Nation, of Delaware origins. North of what would become New York City, the Lenape inhabitants had some Algonquin connections.

Explorer Giovanni Verrazano discovered this New World harbor in 1524, beckoning future visitors. Ten years later, the Dutch established New Netherland, a harbor and trading port. The British, settling New England's coast in the 1600s (including today's eastern Westchester County), seized Dutch territories in an essentially bloodless action. Upon occupying the area and naming the harbor town for York, England, tensions receded as the British granted generous rights to the assimilating Hudson Valley Dutch, who prospered among the British.

The Dutch settled north, up the Hudson River Valley to the French frontier near Albany. The British preferred coastal settlements, notably up the Atlantic coast.

A much larger Westchester, encompassing several adjacent New York counties, was among the 12 original counties within the British Province of New York in 1640.

Commerce and transportation were largely limited to the waterways meeting the Atlantic. Local foodstuffs like grain and produce, mining ore, and lumber came from small Westchester harbors such as Sleepy Hollow, Rye Cove, Peekskill, New Rochelle, Port Chester, Dobbs Ferry, and Sparta, near Ossining. All competed in trade, with New York craving the distinction of being the next major international port of commerce. The Hudson River and Long Island Sound were early figurative railways that were starting to feed a new city.

Through the 1700s, good farmland, important waterways on both sides of the county, fresh water, and an incoming population initiated stable prosperity. Agriculture migrated inland using old native trails, eventually evolving into primitive roads, and then turnpikes or post roads of widely varying standards. Boston Post Road, by the late 1600s, had evolved from the native Pequot Nation path. Southern Westchester County had a few crude east-west accesses. Many of these paths started as wildlife corridors but widened with time.

Ships under sail dominated commerce through the mid-1800s. Getting goods like flour or produce to waterways depended upon horse-hauled drayage. A few stagecoach and mail routes ran through Westchester, including a Boston–New York service that started using the county's Boston Post Road in 1786; three times a week was a common rate for these trips. While eventually railroads made stages obsolete, stages moved on to several lesser county routes, meeting railheads to connect the newer, more remote communities. Perhaps several dozen passengers used stage services in the county on any given day. After the American Revolution, 25,000 people lived in the county in 1790, which then included the Bronx. The Bronx would be part of Westchester County until 1898, when it became its own county, joining New York City.

By 1825, when the county's population was about 35,000, New York State became a leader in American transportation. The Hudson River became the nation's primary westward access route,

meeting the new Erie Canal at Albany, which continued to Buffalo, accessing the Great Lakes and much of the continent. The county, like New York City, had priceless Western access.

Also in 1825, the world's first steam-powered railway began operation in England. The 25-mile Stockton & Darlington Railway allowed coal conveyance from collieries inland to sea-borne transport. Before that, a handful of primitive, mostly short-line railroads existed that relied on muscle power. This true railway began a boom that accelerated the Industrial Revolution. Steam engines dated to the 1600s, but it took many years of refinements to make them safe, powerful, and portable enough to fit atop wheels—in other words, railway equipment. Before railroads, steam engines were less portable, powering first factories and then ships.

With steam railways perfected, the first American steam railroads were capitalized almost immediately, and by the 1830s, several were in operation, initially relying partly on British-built equipment. Westchester, mostly agrarian but with a handful of small mills and mines, had to wait until the 1840s to see its first railroad built north from Manhattan, which at the time had about 200,000 residents concentrated mostly south of Twenty-Third Street but expanding outward.

Our first railroad, the New York & Harlem, started as the brainchild of a carpenter turned coach maker from Ireland, John Stephenson, who was backed by area investors. It was only a downtown street railroad that restricted horses to a stagecoach pace of five miles per hour. Steam power was not permitted in lower Manhattan in 1832.

The earliest carriages were essentially stagecoaches tailored for rail haulage. The configuration and size of these coaches evolved during the ensuing years from the 1830s toward a larger, more conventional coach by the 1850s.

The New York & Harlem, often called "the Harlem," grew from serving lower Manhattan's Park Place, city hall, and Prince Street and built ever northward, progressing north up Fourth Avenue, renamed Park Avenue in 1888, reaching Forty-Second Street in 1834 before crossing the Harlem River into the Bronx in 1840, and then on into Westchester County. The railroad rapidly progressed to White Plains by 1845.

The New York & Harlem revised its earlier Manhattan-only charter destined to terminate at 135th Street and the Harlem River. The owners sought expansion north through the center of Westchester, heading inland to access a westward rail connection near Albany. The Harlem's progress was delayed by daunting granite above Croton Falls but reached Chatham and its westward connection with the Boston & Albany Railroad by 1852. Eventually, both companies were within the same system, the later-built Hudson River Railroad, but the Harlem's rival had reached Albany a year sooner. Westchester County of the 1840s benefited from Manhattan's importance as more rail projects progressed through the county. In general, investors worldwide were easily enticed to this "sure thing" of railroads, and raising capital was rather easy.

A second line came down Long Island Sound's inner shoreline from New England in 1844, the New York & New Haven Railroad. It was essentially a trunk-line extension of the rapidly expanding New England railway network. The New York & New Haven reached Grand Central in New York City, but only through a court-ordered tenant trackage rights agreement with a reluctant landlord, The New York & Harlem, which gave the New York & New Haven Manhattan access at Woodlawn Junction. Eventually, the New Haven built a freight line to the Harlem River in the east Bronx in 1873, giving this shore route greater importance by allowing access to New York Harbor. This line gained even more utility when the Hell Gate Bridge to Penn Station opened.

The third railway, a relative latecomer in 1849, was the Hudson River Railroad. Delayed for several years by river shipping and competing with Harlem Railroad interests, the Hudson Railroad became the busy mainline of the New York Central System under a titan who would combine the Hudson and Harlem Railroads to a new Grand Central Depot. Cornelius "Commodore" Vanderbilt was also buying up westward lines to sew into an eastern rail empire reaching Midwestern hubs in Chicago, Cincinnati, and St. Louis.

Westchester's first three railroads—Hudson, Harlem, and New Haven—were largely in place and well used by 1851. In many respects, these three lines became busy railroads of permanence and are still important in commerce. Today, the Metropolitan Transit Authority (MTA) Metro-

North and Amtrak haul passengers. Freight carriers CSX Transportation and the Providence & Worcester Railroad keep freight trackage operating rights.

Freight once played a significant role in the county's growth and commerce, handling virtually all land commerce until the mid-20th century, but has mostly declined ever since. That was unthought of, however, a century ago.

The generations around the turn of the 20th century saw the peak in the worldwide railway boom, particularly in the Northeast, fed by Northern post–Civil war prosperity, population growth, and the continuing Industrial Revolution.

In addition to investors and financiers, the rail industry had its romantic side of backers, dreamers, and progressive thinkers who became enamored with the new overland transport mode that was revolutionizing daily life in America; even the now impoverished South was getting rail investment, often by Yankee backers, some of whom empathized with the South's plight. Among those was rail titan Commodore Vanderbilt.

For the rail industry, the late 1800s was an era of accelerating technological advances. Ironmaking transitioned to steel manufacturing, allowing stronger and far safer rails and rolling stock. Inventions such as the Westinghouse air brake system, knuckle car coupling devices, and automatic safe signal systems, initially deemed too costly by railroads, had their efficiencies, which railways eventually embraced and still use today. There was an ample crop of post–Civil War army officers from the North and the South capable in civil and mechanical engineering qualified to expand America's railway system.

During the county's peak years in rail mileage and general use, 1912–1931, Westchester had five principal rail lines of varying volume plus five short branch lines. Streetcar lines once served the busier communities, a forgotten part of county transportation between 1888 and 1952.

This book attempts to present mostly older images. Many buildings, old right-of-ways, stations, telegraph poles, and a rusting piece of a bridge in Tarrytown Heights (not pictured in this book) are among the relics one can find today. Even riding today's contemporary rails, passengers can look out the window and find history.

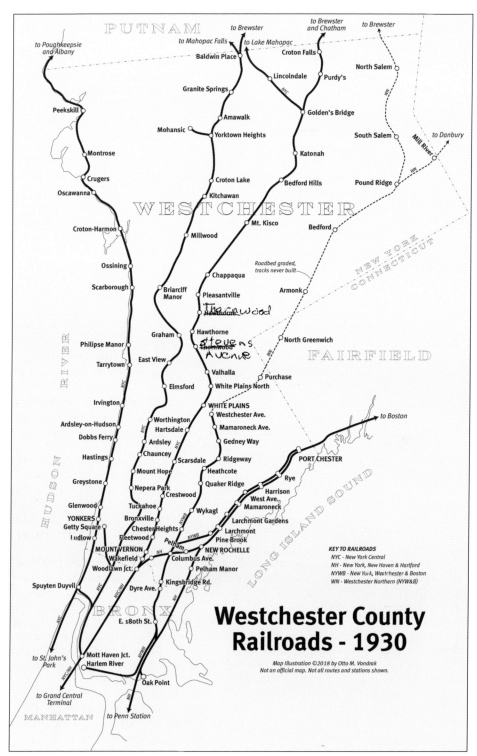

This is a rendering of Westchester's rail lines at their 1930 peak. There were six lines versus today's three. Other maps can be found on pages 106 and 120. (Map by Otto M. Vondrak.)

One

RAILWAYS ARRIVE
IN WESTCHESTER

Westchester's first county railroads—the Harlem, the Hudson, and the New Haven—all arrived in Westchester between 1840 and 1851 and were busy from the start. Early investors were generally local denizens and business people, anxious to get their town on the map, reap the fruits of travel, and economically ship or receive goods. These early rail builders hardly thought of the massive national rail network that would develop with the next generation of investors, earning the name "industrialists."

The growing traffic revenues and improving technology of the 1860s meant faster and heavier trains that hauled increasing tonnage over longer distances. Rails caught the eyes of the new higher-profile industrialists, such as J.P. Morgan, James Fisk, Jay Gould, Andrew Carnegie, and Cornelius "Commodore" Vanderbilt.

Vanderbilt's interest in marine shipping business shifted toward railroads and their massive potential around 1863. He would take a handful of new, smallish railroads between New York and the Midwest to link up with the fledgling Western railroads underway toward the Pacific. Vanderbilt had the rare talent of turning pipe dreams into reality, soon dominating New York State and Westchester's railway industry, and sewed together an unprecedented rail network. Locally, after Vanderbilt acquired Westchester's Hudson Railroad, he acquired the Harlem and Putnam Railroads, largely to ward off competition, tightening his system.

Westchester's New York & New Haven, later New York, New Haven & Hartford (NYNH&H), also called "the New Haven" for short, was a route backed by New England and Boston investors anxious to link to New York City and busy from its 1844 beginnings. The New Haven had a history of prosperity and financial misfortunes.

Toward the 1870s, New Haven's investors narrowed down to mostly a small clique led by J.P. Morgan and a few lieutenants, lasting until Morgan's 1912 passing, which resulted in some corporate turbulence. Unlike the New York Central—a Vanderbilt outfit until 1954, when it became a public corporation—the New Haven reorganized through much of its financially tumultuous history, making it a great study.

Most county rail travelers gravitated to New York City when Grand Central opened in 1871. Exponential traffic growth required station rebuilds and hodgepodge expansions. In 1913, the new electrified Grand Central Terminal (GCT) opened. Many infrastructure improvements that supported GCT's operation, such as Harmon Shop, electrification, and added trackage, were made in Westchester.

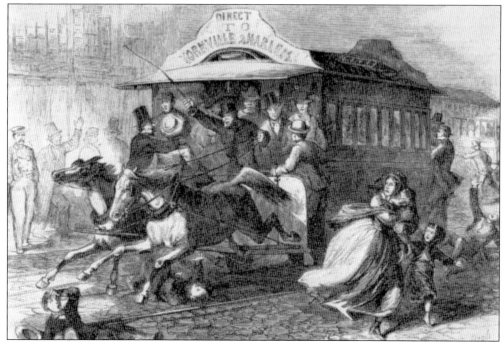

This horse-pulled car was typical of the earliest passenger Harlem rail coaches—an extended stagecoach on 1832's New York & Harlem Railroad. Much of the early city tracks were not on paved streets but rather a dirty, muddy right-of-way beside the street. Trackage started between Prince and Fourth Streets, only .085 miles long, in November 1832. This railway started as a streetcar franchise leased out by the city, which then excluded the Bronx. The remote and pastoral Westchester had just 40,000 residents. (Courtesy of the Library of Congress.)

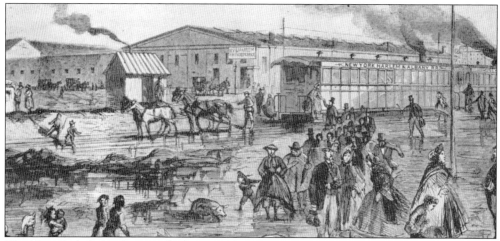

The New York & Harlem reached Forty-Second Street in 1834, but with ambitions beyond Manhattan, it later acquired the unbuilt New York & Albany's assets in order to gain certain properties and a needed charter northward. The name New York, Harlem & Albany Railroad was briefly used as shown in this 1850s chaotic scene at the pre–Grand Central Forty-Second Street transfer station, as loud, smoky steam was banned south of here. Horses were used for "horse-pulls" instead. Stables and an older station were kept at Twenty-Sixth Street, even past Grand Central Depot's 1871 opening. (Courtesy of the Library of Congress.)

Railroads helped to foster new businesses, such as this 1840s advertisement for a new stage service linking the Armonk area. Although the original New York & Harlem was chartered to only reach the river at Harlem, resistance to new railroads existed but paled in the face of those who wanted them. The county's growth helped displaced stage operators find new opportunities to service new communities, many of which blossomed throughout the 1800s. County localities began as early as the 1600s, but more remote settlements came together in the later 1700s. (Courtesy of the New York Central System Historical Society.)

With an 1846 charter, the New York & New Haven Railroad arrived in Westchester's shoreline towns. The New England–owned railroad never built tracks into Manhattan, instead utilizing New York & Harlem tracks from Woodlawn south of today's Westchester-Bronx County boundary. A healthy traffic volume dictated that a second track be built by 1854. The other two main county railroads made similar enhancements. (Courtesy of the Westchester County Historical Society.)

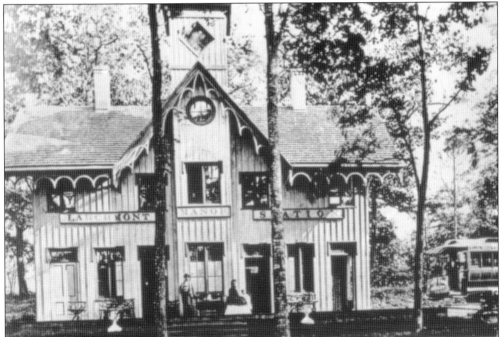

The Hudson River Railroad was Westchester's third line, starting partially in 1849; this image shows Croton-on-Hudson's early depot, before Croton Harmon became a major station and facility. This line reached the Albany area by 1851, beating the New York & Harlem, and was founded by Hudson Valley investors who tired of the winter isolation from a frozen river. Prior to its 1846 charter and ground breaking, shipping interests successfully delayed the line, but only temporarily. When green-lighted, it progressed fast, with the Hudson River's shore being less full of obstacles than anticipated. (Courtesy of the Croton-on-Hudson Historical Society.)

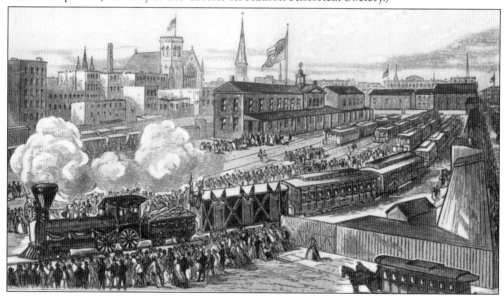

Shown is President Lincoln's funeral train departing Manhattan, heading to the Hudson River Railroad's New York passenger terminal and on to Renneslaer, New York. A low-keyed James Boorman was Hudson River Railroad's first president, but the day of high-profile tycoons was approaching. This 1865 print shows a railroad that was then under Vanderbilt ownership; within six years, Grand Central Station would open with trains diverted to the northern edge of the city. This portion of the railroad became the West Side Freight Line. (Courtesy of the New York Central System Historical Society.)

HUDSON RIVER RAILWAY.

Commodore C. Vanderbilt, President; Wm. H. Vanderbilt, Vice-Pres.; J. M. Toucey, Gen. Supt.; J. Burdett, Asst. Supt.; and C. H. Kendrick, Gen. Ticket Agent, New York. [April 26.

| New York to Albany and Troy. | | | | | | | | Troy and Albany to New York. | | | | | | | | |
| Pass. | Exp. | Exp. | Pass. | Exp. | Exp. | Pass. | Mls | STATIONS | Exp. | Exp. | Exp. | Exp. | Mail | Exp. | Mxd | Pass. |
P.M.	P.M.*	P.M.	P.M.	A.M.	A.M.	A.M.		LEAVE · ARRIVE	A.M.*	A.M.	A.M.	P.M.*	P.M.	P.M.	A.M.*	A.M.
							0	..New York..								
11 00	6 30	4 00	2 30	10 45	8 00	6 45	3	..30th street..	7 00	9 20	11 45	3 30	6 15	9 30	1 50	6 00
							8	..Manhattan..								
							9	..152d street..								
							10	.Ft. Washington.								
							13	.Spuyten Duyvel.								
							14	...Riverdale....								
							15	.Mt. St. Vincent.								
		3 04		11 19		7 20	17	Yonkers					5 40	8 59		
		3 07				7 23	18	...Glenwood....					5 33			
		3 14				7 30	21	...Hastings...					5 25			
12 10		3 20				7 36	22	..Dobbs' Ferry..					5 22		12 43	4 57
		3 26				7 42	24	...Irvington [1]...					5 13			
12 28		3 34		11 41		7 50	31	...Tarrytown [2]...					5 07	8 38	12 23	
		3 42				7 57	32	..Scarborough..					4 57			
12 47		3 48		11 54		8 04	32	...Sing Sing....					4 53	8 26	12 00	
		3 55				8 12	36	...Croton....					4 43		11 35	
		4 02				8 19	37	...Cruger's....					4 36			
		4 07				8 24	41	...Montrose....					4 31			
1 22	8 06	5 23	4 18	12 17	9 21	8 33	43	Peekskill....	5 35	8 10	10 23	2 11	4 25	8 06	11 10	
		4 26				8 42	47	Ft. Montgomery.					4 10			
	8 26	5 41	4 38	12 35	9 39	8 53	51	..Garrison's [3]...		7 50	10 02	1 51	4 01	7 46	10 38	3 29
		5 48	4 45	12 42		9 00	54	..Cold Spring. ..		7 44	9 55		3 53		10 28	
			4 51			9 06	56	.Cornwall Station.					3 44			
2 13	8 47	6 02	5 00	12 55	9 56	9 14	60	..Fishkill [4]...		7 31	9 42	1 31	3 37	7 29	10 06	
			5 07			9 20	64	..Low Point..		6 23			3 27		9 48	
		6 16	5 15	1 08		9 28	66	.New Hamburg..		7 18	9 29		3 21		9 40	
			5 25			9 38	71	..Milton Ferry..		7 08			3 10		9 18	
3 05	9 27	6 45	5 45	1 35	10 33	11 00	75	Poughkeepsie.	4 28	7 00	9 10	1 00	3 00	7 00	9 05	2 17
		6 59	5 59	1 48		11 14	80	..Hyde Park....		6 42		12 39	2 34		8 35	
		7 10	6 10	1 58		11 25	85	...Staatsburg. ..		6 32		12 29	2 23		8 20	
3 53	10 03	7 22	6 22	2 10	11 02	11 37	90	...Rhinebeck....		6 21	8 28	12 18	2 11	6 20	8 05	1 20
		7 35	6 35	2 23		11 51	96	...Barrytown....		6 09		12 06	1 56		7 46	
4 27		7 47	6 47	2 35	11 24	12 04	100	...Tivoli....		5 59	8 08	11 57	1 45	6 01	7 30	12 52
		8 00	7 00			12 18	105	Germantown ..		5 47			1 30		7 09	
		8 13	7 12	2 58	11 45	12 32	111	Catskill Station..		5 35	7 45	11 35	1 16	5 38	6 51	
5 13	11 01	8 25	7 20	3 10	11 56	12 45	115	Hudson [5]...	2 57	5 25	7 35	11 25	1 04	5 28	6 36	11 59
		8 35				12 57	119	...Stockport...			7 23		12 51		6 20	
		8 43		3 26		1 06	123	Coxsackie Station			7 15		12 42		6 10	
		8 50		3 33		1 14	125	...Stuyvesant..			7 08	11 00	12 34		6 02	
		9 03				1 29	132	...Schodack....			6 55		12 19		5 46	
		9 12		3 53		1 40	135	...Castleton....			6 47	10 41	12 10		5 34	
6 35	12 05			4 10	12 50	2 00	144	...East Albany...			6 30	10 25	11 50	4 30	5 15	10 40
6 45	12 15	9 40		4 20	1 00	2 05	150	Albany [6]...	1 55		6 20	10 15	11 40	4 20		10 30
7 00	12 30	9 50		4 35	1 15	2 20		Troy [7] ..			6 05	10 00	11 30	4 05		10 00
A.M.	A.M.	P.M.	P.M.	P.M.	P.M.	P.M.		ARRIVE · LEAVE	A.M.	A.M.	A.M.	A.M.	A.M.	P.M.	P.M.	P.M.

☞ Trains marked thus (*) run daily. Other trains, Sundays excepted.

1 Ferry to Piermont (terminus of Piermont Br. of Erie Railway).
2 Ferry to Nyack. 3 Ferry to West Point.
4 Ferry to Newburg (terminus of Newburg Br. of Erie Railway).
5 Connects with Hudson & Boston Railway.
6 Connects with New York Central Railway.
6 Connects with Albany & Susquehanna Railway.
7 Connects with Troy & Boston Railway.
7 Connects with Rensselaer & Saratoga Railway.

LOCAL TRAINS, stopping at Way Stations.

Yonkers.—Leave 30th street for Yonkers at 6 30, 7 10, 9 00, 9 40 & 11 50 A. M., and 2 00, 4 25, 5 10, 7 10 & 11 30 P. M. Leave Yonkers for New York at 6 00, 7 50, 8 20 & 10 00 A. M., and 12 30, 2 40, 3 20, 5 50, 6 40 & 9 10 P. M.

Sing Sing.—Leave New York for Sing Sing at 5 30 & 6 00 P. M. Leave Sing Sing for New York at 6 20 & 7 55 A. M.

Peekskill.—Leave New York for Peekskill at 10 00 A. M. and 4 15 & 7 00 P.M. Leave Peekskill for New York at 6 35 & 8 20 A. M., and 12 30 P. M.

Poughkeepsie.—Leave New York for Poughkeepsie at 12 00 noon, and 5 00 P. M. Leave Poughkeepsie for New York at - — A. M.

Emigrant Train leaves New York at 8 00 P. M., arriving at East Albany at 6 25 A. M.

This is an example of the Hudson River Railway's principal 1869 timetable, six years after Commodore Vanderbilt began acquiring the Hudson, Harlem, and westbound lines. Grand Central access was still two years off, but that plan was underway. For several years leading to 1871, the Vanderbilts' Harlem and Hudson Railroads ran separately, were landlocked apart, and well before this schedule was printed, were competitors. (Courtesy of the Croton-on-Hudson Historical Society.)

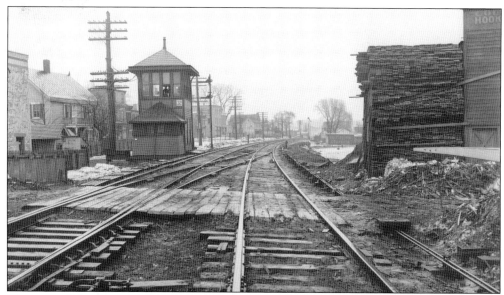

This view of Croton-on-Hudson from about 1899 still shows the simple two-track mainline of the Hudson River Railroad, now named the New York Central and Hudson River Railroads, after merging with numerous carriers in the state. Of note is the signal tower, built with interlocking route protection. An automatic safe and modern block signal system (ABS) was in place, giving protection to a growing volume of traffic. Other safety measures had by now fallen into place, such new vestibuled steel passenger cars replacing wooden ones. (Courtesy Croton-on-Hudson Historical Society.)

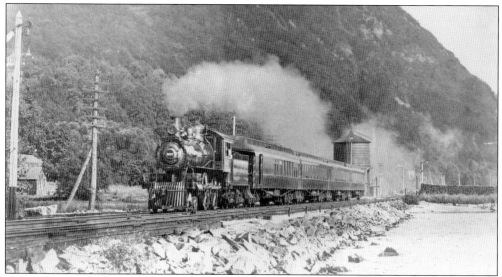

This train, shown in the late 1800s, is the New York–Buffalo Empire State Express north of Peekskill near today's Hudson Highlands State Park. By now, Vanderbilt lines reached throughout the Midwest east of Chicago and included a growing fleet of long distance trains, some of which were used to connect with West Coast–bound trains. Westchester residents enjoyed long-distance train service west from Yonkers, Croton-Harmon, and Peekskill. Smaller river villages offered connecting trains. Today, one can still travel via Amtrak to Chicago daily from Croton-Harmon. (Courtesy of the New York Central System Historical Society.)

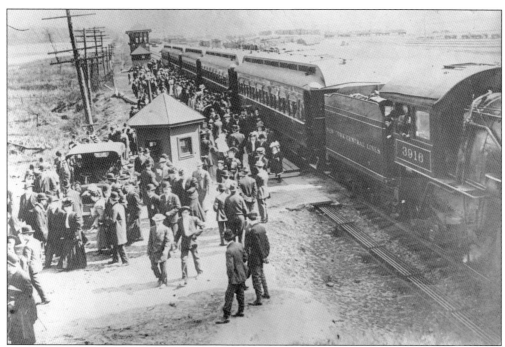

Commuter traffic increases continued after the 1840s, barring financial panics, wars, and epidemics. This early 1900s view of Croton-Harmon is from just before this station and large facilities were built up. However, Harmon real estate developer and pioneer aviator Clifford B. Harmon was aggressively marketing Croton's suburban property, advising these prospective homebuyers that electric train service was coming with just a 45-minute trip to New York. The railroads were outgrowing the steam era. (Courtesy of the Croton-on-Hudson Historical Society.)

Pictured here second from left on Track 19 is a Peekskill local. At left, Track 20 shows marking for the 20th Century Limited later on. Although a passive scene, outside this London–St. Pancras station–inspired depot and shed, many annex tracks were added since opening in 1871. Traffic growth warranted that approach tracks increase to four via trench-tunnel and viaduct to Harlem. At times, steam and smoke obscured vision, causing some fatal accidents and an outcry for smokeless propulsion and electric traction. (Courtesy of the New York Central System Historical Society.)

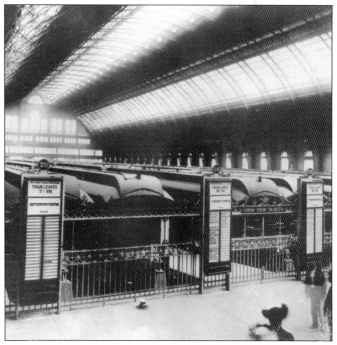

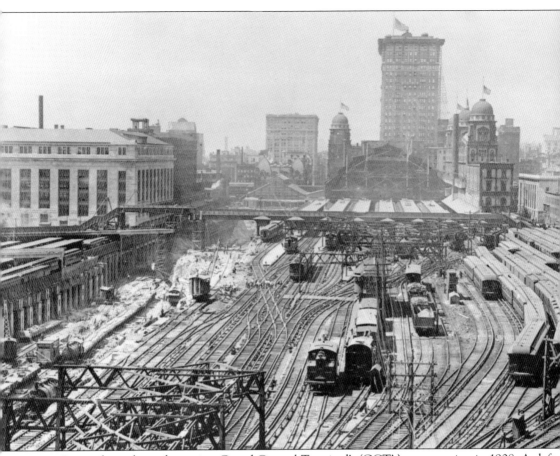

Pictured is a three-phase view Grand Central Terminal's (GCT's) construction in 1908. At left is the newly completed post office building; part of this complex shows underneath numerous new platforms and tracks in service. Steel pilings block the view of lower level construction. Left of center is the carved-out stone and earth being prepared for another part of the terminal. At center is a still-busy portion of the old station, used until the new terminal could accommodate shifting traffic to the next completed portion—about two years off. Of note is new electrification, as mostly all tracks are third rail equipped. The overburdened coach yard at right shows about 70 various passenger and mail cars likely in day storage. Six pieces of new electric motive power (motors) are visible, including one New Haven unit. New Haven also had to transition to electric in concert with New York Central. The first generation of skyscrapers seen here would change again post-completion, with bigger towers and hotels that covered the new tracks. The half-staff flags seen here on June 26, 1908, are for former president Grover Cleveland, who had just passed away. (Courtesy of J.W. Swanberg.)

Two

THE HARLEM LINE

The New York & Harlem Railroad, as the region's first line, was initially supposed to go from city hall, north up Fourth Avenue, and terminate at a dock on the Harlem River around 135th Street. Technology and the city's growth outward changed parameters, and this 1832 street railway had investors craving northward expansion.

Likeminded legislatures of the forward-thinking era facilitated legalities, allowing a fast build northward, reaching White Plains by 1846. The Harlem's objective was to reach a link west via the Boston & Albany Railroad in Chatham, New York.

Somers-Granite at Croton Falls, the northernmost county station, delayed construction there in 1848–1849 but reached Chatham in 1852. This unfortunate costly delay allowed a latecomer, the Hudson Railroad, to finish end-to-end a year sooner.

The Harlem was briefly named the New York, Harlem & Albany Railroad after buying the charter, some right-of-way lands, and assets of the distressed never-built namesake railroad; the Harlem merged with this stalled railroad mainly for its papers of building rights.

Above Manhattan, it climbed a minor Bronx scarp and followed the well-positioned Bronx River to near Hawthorne, then followed the Saw Mill River valley to Mt. Kisco's outskirts. With scenic portions throughout, the railroad crossed another minor rise to skirt hills along Croton River tributaries toward a climb above Croton Falls. Eventually, northward wetlands and the Great Marsh are crossed. An uneventful crossing of the Appalachian Trail is in the southern Harlem Valley, about 20 miles north of the Westchester County line before Taconic-Berkshire terrain prior to reaching Chatham.

Never becoming the mainline west, it became a busy commuter mainline between Brewster in Putnam County through Westchester County to New York City with a passenger volume thickening southward through Westchester's dense towns. The busy New Haven line joins at Woodlawn, where it becomes a four-track railroad, south of Mount Vernon West. Hudson line trains also join the Harlem line at Mott Haven, six miles north of Grand Central Terminal.

Today, the Harlem line truncates at Wassaic, with old trackage above abandoned. It is now largely a scenic bike trail. The still active 88 miles of railroad, in respect to passenger traffic, are busier than ever as far as Westchester is concerned. It is the county's longest line within its borders and carries the most passengers.

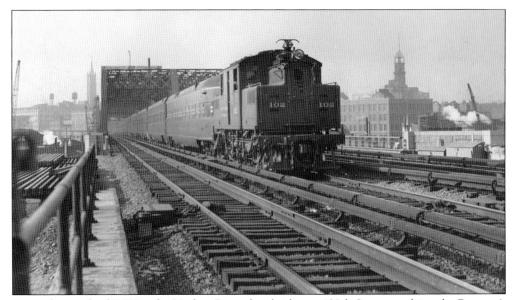

Five miles north of GCT is the Harlem River drawbridge, at 138th Street reaching the Bronx. A 1904-designed S-2 electric motor is seen hauling cars of a major train from Chicago, about a half mile farther for cleaning and servicing in the massive Mott Haven Yard just above this location. Mott Haven is also where the Hudson line diverges west to Croton-Harmon and beyond. The busy New Haven, also using these tracks, easily warrants a four-track mainline to Woodlawn near Westchester's post-1898 border, roughly six miles north. (Courtesy of the New York Central System Historical Society.)

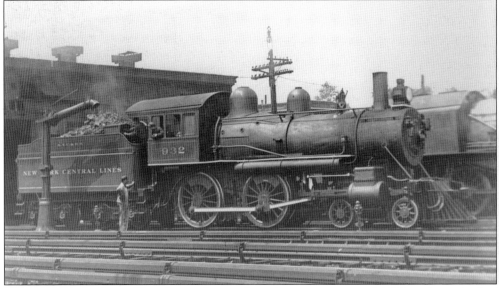

Wakefield, by the Bronx-Westchester County boundary, is seen around 1907 in the early days of Grand Central electrification. Wakefield was a temporary engine change point similar to the Hudson Line at High Bridge. Electrification from New York was implemented in construction phases on all lines. This locomotive, just serviced and ready to haul a westbound train, is one of New York Central's 1896-built fast 4-4-0 American type passenger locomotives, and was among the last batches of these types built. (Courtesy of J.W. Swanberg.)

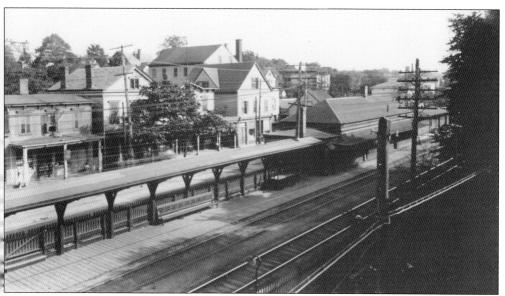

This image of Mount Vernon station shows the old depot before grade separation was phased in between 1910 and 1919, often requiring new stations and platforms. Mount Vernon was once considered a big manufacturing town and could still boast two railroads serving it to this day. It had three railroads until 1937. A border town adjacent to the Bronx borough of New York City, residents debated joining Bronx County in a referendum in 1898. (Courtesy of the Westchester County Historical Society.)

This August 1916 Bronxville photograph taken at the Pondfield Road crossing betrays any belief that all grade crossings vanished from lower Westchester before the new electric trains and the current Grand Central Terminal arrived. With a Mission-style Gramatan Hotel behind the hand-operated gates, a gateman is checking out the scene of people and vehicles over a cigar. A small piece of a third rail is visible at right. Here, roads were soon separated from the track grade with room to allow four tracks. (Courtesy of the Westchester County Historical Society.)

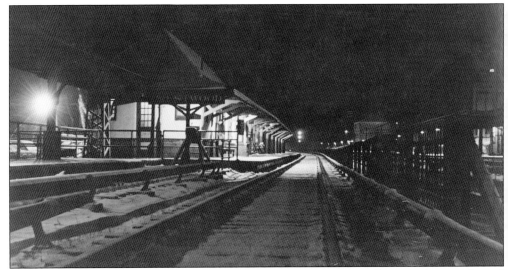

Crestwood station in Eastchester, pictured here in the 1960s, had a small interlocking eastbound and westbound fast-passing track rating most hours, allowing operating flexibility, such as placing a local freight train in the "clear" while an express could whisk by on the main track. These sidings gave the railroad a substantial four-track look, albeit under one mile. The additional stub track at left was used for a handful of originating peak-hour trains. To the south, a small yard extended toward the Tuckahoe station and did a variety of duties from the mid-1800s for both stations. (Courtesy of the Westchester County Historical Society.)

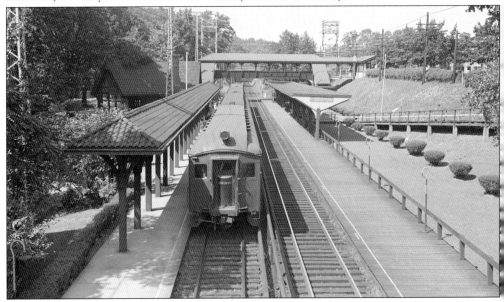

Scarsdale's 1906 Tudor station set the village centers' architectural tone, which included some of Eastchester, and blossomed Scarsdale into a commuter-oriented village ideal for walking to transportation, restaurants, shopping, and more. A building trend of nearby elevator-equipped apartment buildings began with a mix of classic-styled buildings on tree-lined streets, notably Garth Road, making it a good example taught in urban planning. This photograph appears to be from the 1920s, with an electric Multiple Unit Train (MU). Scarsdale dates to 1701 and was home to James Fenimore Cooper. (Courtesy of the Westchester County Historical Society.)

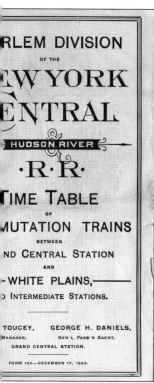

RLEM DIVISION
OF THE
W YORK
ENTRAL
HUDSON RIVER
·R·R·
TIME TABLE
OF
MUTATION TRAINS
BETWEEN
ND CENTRAL STATION
AND
—WHITE PLAINS,—
INTERMEDIATE STATIONS.

TOUCEY, GEORGE H. DANIELS,
MANAGER. GEN'L PASS'R AGENT.
GRAND CENTRAL STATION.

FORM 160—DECEMBER 17, 1893.

WEEK-DAY TRAINS TO GRAND CENTRAL STATION.

White Plains	Hartsdale	Scarsdale	Tuckahoe	Bronxville	Mt. Vernon	Washington-ville	Woodlawn	Williams Bridge	Bedford Park	Fordham (See Note)	Tremont (See Note)	Claremont Park (See Note)	Morrisania (See Note)	Melrose (See Note)	138th St. Mott Haven	125th St. Harlem	110th St.	86th St.	Grand Central Station (Arrive)
			5.29½	5.30½	5.35½	5.37½	5.40½	5.43½	5.45½	5.48½	5.51½	5.53½	5.55½	5.57½	6.02½	6.05½	6.07½	6.10½	x6 16
5.35½	5.39½	5.43½	5.49	5.51	5.56		6.00	6.03	6.05	6.08	6.11	6.13	6.15	6.17	6.21	6.24	6.26	6.29	6.35
		6.20	6.22	6.26	6.28			6.30	6.34	6.36	6.39	6.42		6.48	6.52	6.55	6.57		x7.05
6.18	6.22	6.26	6.32	6.34	6.39		6.43	6.46	6.48	6.51	6.54	6.56	6.58	7.00	7.04	7.07	7.09	7.12	7.20
6.24	6.37	6.40	6.49	6.51	6.56		7.00	7.04	7.06						7.14				7.25
7.02	7.06	7.11	7.17	7.19	7.25	7.26	7.29	7.32	7.34	7.37	7.40	7.42	7.45	7.47	7.38	7.41	7.43		8.04
7.25	7.29	7.33	7.39	7.41	7.46		7.50	7.53	7.55	8.01	8.03	8.05	8.08		7.51	7.54			8.26
7.40					7.54									8.08	8.12	8.15	8.17		8.20
8.04	8.08	8.13	7.54	7.56	8.01	8.03	8.06	8.09	8.12	8.14	8.17	8.19	8.21	8.23	8.27	8.30	8.33	8.36	8.44
			8.30	8.32	8.37	8.39	8.41	8.44	8.46	8.49	8.52	8.54	8.56	8.58	8.43				8.53
8.47					9.02									9.02	9.05	9.07			9.15
8.34	8.58	9.03	9.09	9.11	9.16		9.19	9.22	9.24	9.27	9.30	9.32	9.34	9.36	9.41	9.43			9.25
9.39	9.42	9.46	9.53		9.59										10d13				9.53
			9.58	10.00	10.04	10.06	10.08	10.11	10.13	10.16	10.19	10.21	10.23	10.25	10.29	10.32	10.34		10.24
			10.38	10.40	10.45	10.47	10.50	10.53	10.55	10.58	11.01	11.03	11.05	11.07	11.11	11.14	11.16		x10.42
10.50	10.54	10.58	11.04	11.06	11.10		11.13	11.16	11.18	11.21	11.24	11.26	11.28	11.30	11.34	11.37			x11.24
11.13															11d39				11.47
11.50	11.54	11.58	11.55	11.57	11.42	11.44	11.46	11.49	11.51	11.54	11.57	11.59	12.01	12.03	12.08	12.11	12.13		11.50
12.50	12.54	12.58	12.03	12.05	12.10		12.13	12.17	12.20	12.22	12.25	12.27	12.30	12.32	12.36	12.38			x12.22
			1.04	1.06	1.10														12.48
1.40	1.44	1.48	12.55	12.57	1.02	1.04	1.05	1.08	1.10	1.13	1.16	1.18	1.20	1.22	1.22	1.25			1.35
1.56			1.53	1.55	2.00		2.03	2.06	2.09	2.12	2.14	2.16	2.18	2.20	2.24	2.27	1.30		x1.38
2.20	2.24	2.28			2.11										2.25				2.37
3.20	3.24	3.28	2.33	2.35	2.40		2.43	2.46	2.48	2.51	2.54	2.57	2.59	3.01	3.05	3.08			2.35
			3.00	3.02	3.07	3.69	3.11	3.14	3.17	3.20	3.23	3.25	3.27	3.29	3.33	3.36	3.38		3.38
			3.33	3.35	3.40		3.43	3.46	3.48						3.07	4.00			x3.46
4.05			3.45	3.47	3.52	3.54	3.56	3.59	4.01	4.04	4.07	4.09	4.11	4.13	4.17	4.20	4.22	4.25	4.10
					4.20										4d33				x4.31
4.35	4.39	4.43	4.20	4.22	4.27	4.29	4.31	4.34	4.36	4.39	4.42	4.44	4.46	4.48	4.52	4.55	4.57		4.45
			4.48	4.50	4.55		4.58	5.01	5.03	5.06	5.09	5.11	5.13	5.15	5.19	5.22			x5.05
5.15	5.19	5.23	5.10	5.12	5.17	5.19	5.21	5.24	5.26	5.29	5.32	5.34	5.36	5.38	5.43	5.45	5 48		5.32
6.05	6.09	6.13	5.28	5.30	5.35		5.38	5.41	5.43	5.46	5.49	5.51	5.53	5.55	6.00	6.63			x5.56
6.25	6.29	6.33	6.19	6 21	6.26	6.28	6.30	6.33	6.35	6.38	6.41	6.43	6.45	6.47	6.51	6.54			6.13
			6.30	6.41	6.46										7.01				7.04
			7.00	7.02	7.07	7 09	7.11	7.14	7.17	7.20	7.23	7.25	7.27	7.29	7.33	7.36	7.38		7.13
8.04			7.40	7.42	7.47		7.51	7.54	7.57	7.59	8.02	8.04	8.06	8.08	8.12	8.15	8.17		7.46
8.10	8.14	8.18	8.23	8.25	8.30	8.32	8.34	8.37	8.39	8.42	8.44	8.46	8.48	8.50	8.54	8.57			8.39
9.10	9.14	9.18	9.25	9 27	9.32	9.34	9.36	9.39	9.41	9.43	9.46	9.48	9.50	9.52	9.56	9.59	10.01		9.07
10.15½	10.19½	10.23½	10.29½	10.31½	10.36½	10.38½	10.40½	10.42½	10.45½	10.48½	10.50½	10.52½	10.54½	10.56½	11.03½	11.05½			11½13

NOTE.—At Melrose, Morrisania, Claremont Park, Tremont and Fordham, the doors will be closed one minute before schedule time for the departure of all trains.
d Stops at 138th Street (Mott Haven) only to land passengers from the North.
x Trains so marked are not equipped with baggage cars.
For additional trains from 138th Street and 125th Street, see Hudson Division Commutation Time Table.
Where time is omitted trains will not stop.

This December 1893 lower Harlem schedule shows over 40 weekday trains to Grand Central. Note that running times were not bad given the period. Expresses from the north at White Plains could reach New York in under 40 minutes. On this 1893 schedule, the parent railroad was New York Central & Hudson River Railroad; The Harlem Railroad was reorganized to the Harlem division instead. As part of the "Central" system, trains were technically eastbound and westbound and not north/south until well after MTA Metro-North Railroad's 1983 beginning. This schedule represents about a third of Grand Central's ever-growing passenger traffic. (Author's collection.)

Seen about 1961, busy Hartsdale is technically a hamlet within the town of Greenburgh, offering transit convenience similar to Scarsdale and named after the Hart family. The station architects were Warren & Wetmore, a favorite firm of the New York Central by 1915, when it was built. The Tudor style deviates slightly from the more cathedral-like style typical of that firm. The Warren & Wetmore days were another great time of architecture, building upon the legacy prior to Shepley, Rutan and Coolidge. Countywide, many historic stations still exist. (Courtesy of the Westchester County Historical Society.)

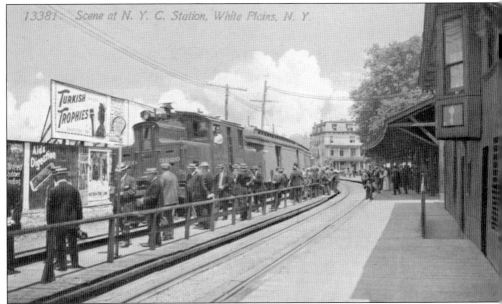

Around 1910, White Plains station was all wood, even to the third rail covering, which was sheathed under wood so passengers could safely step across this simple two-track station. The motor leading this train is a T-2, later reclassified as an S-2. Like most New York Central electric motive power, these motors were jointly built in Schenectady by General Electric (GE) and American Locomotive Company (ALCO). Thirty-four were built, and several worked into the early 1980s. (Courtesy of the Westchester County Historical Society.)

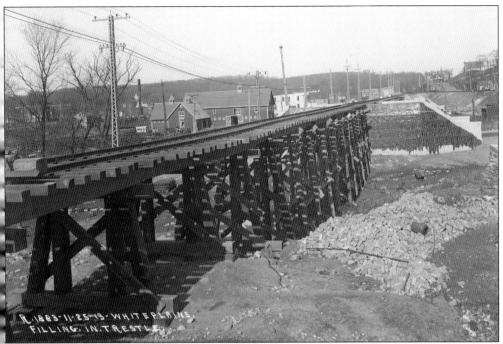

The electric portion of the Harlem division, in keeping with crossing elimination efforts, required measures such as dead-ending secondary streets, building underpasses and bridges, or, as shown here, building fills with principal street access beneath, such as in White Plains. This temporary wooden trestle would be filled with earth and two underpasses for key roads: a widened Main Street and Martine Avenue. The old right-of-way, still in use, is seen at far right. (Courtesy of the New York Central System Historical Society.)

White Plains is seen here about 1914 before completion of its new station while the old station is still in use. While electric service came here in 1910, the new station changed the depot area from the feel of a backward whistle stop to a more presentable urban station. This improvement project was one of many built largely to support the new Grand Central Terminal's electrification. In the foreground is the local freight yard, which stayed in use into the 1960s. (Courtesy of the Westchester County Historical Society.)

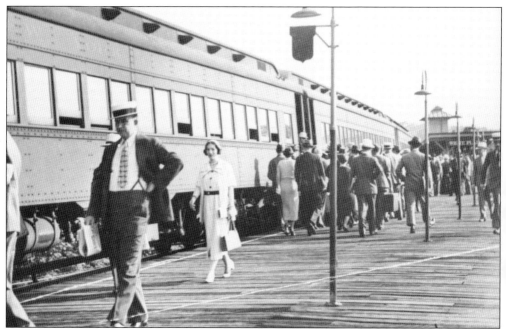

White Plains commuters board a New York express about 1935. As the county seat, White Plains was the largest city on the Harlem line but compact in size and population. Good train service drew passengers here from nearby towns. This 1915 station right-of-way was partly graded and platformed for four tracks if ever needed. Instead, the station kept just two mainline passenger tracks. Beside westbound/northbound Track 1, a third industrial track from a nearby small freight service yard ran to North White Plains, a mile north. (Courtesy of the Westchester County Historical Society.)

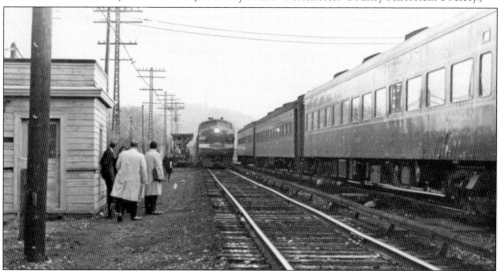

North White Plains station was on the northern—but technically, the western end—of the Harlem's electrified territory before it extended to Brewster in 1984. In this 1968 view showing passengers using a rather minimal station platform, an express from Brewster will stop and change locomotives from the shown diesel to an electric motor into GCT. An electric MU commuter train is at right. Since all trains had to stop here, North White Plains saw its parking lots grow for generations, attracting passengers from a wide area. (Photograph by John Springer.)

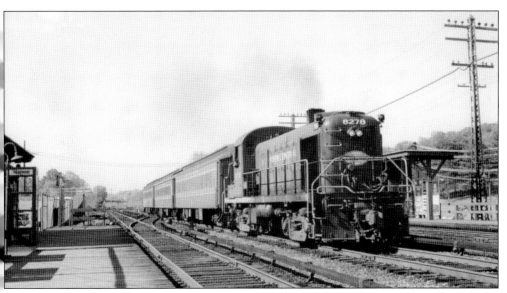

A westbound train to Brewster has just departed Holland Avenue's distant platform, a quarter mile south, as seen from the station proper and the depot. Space limitations required a stretched station arrangement with this track; two platforms were located where this train is passing, and the third, Holland Avenue, was required for westbound trains' engine changes from electric power from GCT, to steam, and later diesel power in 1952, as seen with this Alco RS-3 Road Switcher in the 1960s. Before Holland Avenue was constructed, trains beyond here took no passengers, only changing power. (Photograph by Richard Herbert.)

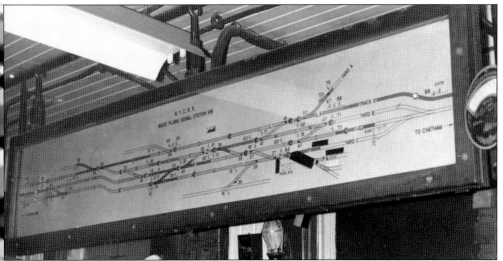

NW Tower's interlocking, which controlled area traffic, referenced this model board to route trains. The platforms bracketed the tracks where "Pass Sta" is shown. Holland Avenue Platform, not shown, was along the bottom track, becoming an industrial track a mile east to the White Plains freight yard. The narrow riverside terrain required an elongated facility and slightly complicated track arrangement. North White Plains required shops, storage yards for about 150 cars, a roundhouse, and servicing capabilities for all modes of locomotive power. (Photograph by John Springer.)

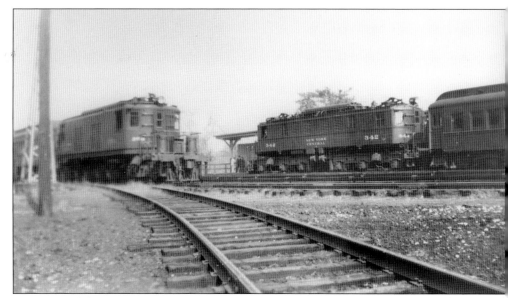

At North White Plains's Holland Avenue platform, an electric motor, one of 42 R-2s from 1930 built by Alco and GE Schenectady, has just arrived from New York and is about to be replaced by steam power. R-2 motors, lacking steam heat in winter, were primarily freight motors. At left, two T-type motors built by the same manufacturer head to New York. The spur in the foreground was one of two small spurs at the southern end of the station. (Photograph by Richard Herbert.)

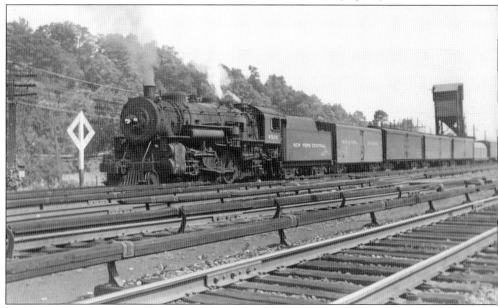

The Rutland Milk was one of 11 New York Central milk trains that once ran through Westchester. Steam power was coupled after electric haulage from New York. The 4-6-2 locomotives, more associated with fast passenger trains, held freight jobs on the Harlem line, as traditional freight power rarely came here. Rutland Milk refrigerated cars were delivered to the Bronx and Manhattan from Chatham and points north. Dairy was a major shipping commodity, traveling this line from upstate and New England. Dairy also traveled via the Hudson line, plus other routes to New York. (Photograph by Richard Herbert.)

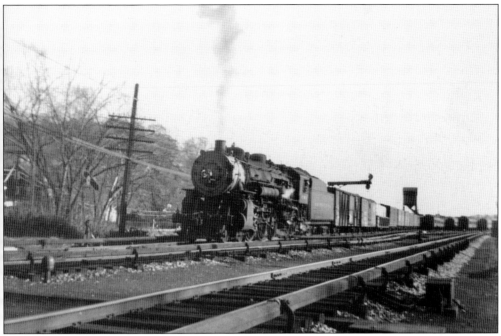

A white smoke box, shown here on engine 4549, was unique to the Boston & Albany Railroad (B&A). The B&A was completed in 1841, joining the New York Central in 1900. About 1946, the B&A got a batch of new steam power and some newly available post–World War II passenger diesels; B&A sent roughly 20 steam engines in a slight modernization of Harlem motive power. In addition to the Rutland Milk, a decent amount of local freight traffic kept this daily freight to Brewster Busy. Freight destined beyond Westchester was also in the consist. (Photograph by Richard Herbert.)

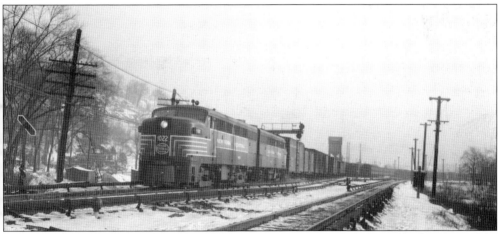

By the 1950s, trucks were eating into the freight business, and dairy traffic disappeared by 1960. However, the Harlem division still rated good road power for its remaining freight. Most localities had local freight customers. Some examples—building materials, lumber, propane, and groceries—went to over a dozen locations. A supermarket warehouse in Mt. Kisco was often good for nearly a dozen cars daily. Freight, coal, and feed were destined beyond Brewster. A pair of ALCO FA-1 diesels lead this West Seventy-second Street–Brewster freight out of North White Plains. (Photograph by Richard Herbert.)

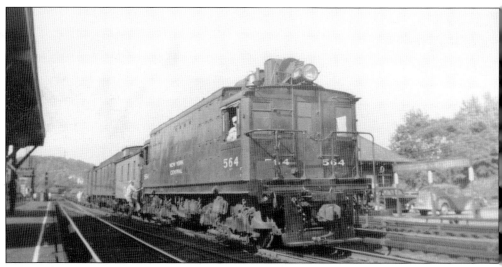

White Plains, North White Plains, and the surrounding area had some local freight business, but not a huge volume. This 1930-built DES-3 was well suited here, also handling some yard and maintenance shop work. Forty-two DES-3s with just 300 horsepower were built as a unique tri-powered unit for electric, diesel, or battery traction. Their niche was working where steam was illegal and an electric third rail was not available, which was the case for numerous customer delivery tracks. Here, it was useful as a light-duty switcher. (Photograph by Richard Herbert.)

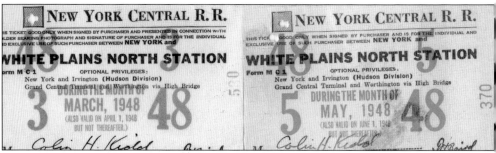

A monthly commutation ticket is something most commuters are familiar with, as it is deeply discounted by roughly a third off regular peak fares; plus, one received unlimited travel, then and now. This ticket was also valid on the Putnam division to Worthington, shy of Elmsford, and Irvington. New York Central's & Hudson River Railroad's name changed with the times. Depending upon the era or need, the New York Central Railroad added "railroad," "lines," or "system" to its name. (Courtesy of Richard Herbert.)

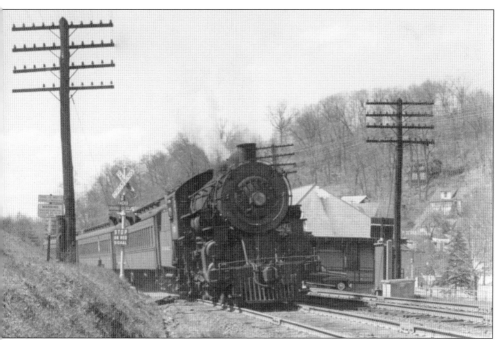

Valhalla, New York, had much of its Kensico hamlet relocated here for the Kensico Dam and Reservoir. This train, seen in 1947, was among the few Mahopac branch trains, which started from Brewster but first traveled via the Putnam line by way of Carmel, Mahopac, and Lincolndale before returning to the Harlem line at Goldens Bridge. The engine was an ALCO 4-6-0, a pre–World War I product. These lighter locomotives were a common indicator that a train took this roundabout route. The Valhalla name originates from Norse mythology. (Photograph by Richard Herbert.)

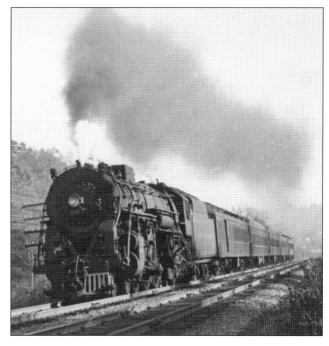

A teenage Richard Herbert of White Plains hiked north of Valhalla on a Saturday afternoon to catch this Chatham bound train that included a diner car and was led by one of 10 ALCO J-3 4-6-4 Hudson-type locomotives. Ten of these well-regarded units were among the B&A motive power relocated here. When developed in the late 1920s, Hudsons were premier passenger locomotives and were given assignments on faster and longer trains. Crews gave these engines high marks. From the late 1940s into 1952, Hudsons handled the Chatham-bound trains and busier Brewster–New York trains. (Photograph by Richard Herbert.)

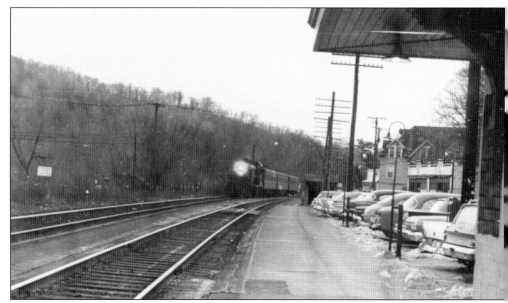

A Brewster–to–New York train approaches Hawthorne in 1966. When beyond the electric territory, the two-track railroad to Brewster had mostly a single main platform with a small island platform. Crews operating trains in opposite directions had to know the schedule and slow or even stop to protect boarding passengers. That practice kept a good safety record up to MTA Metro-North's electrification, replacing steam-era station platforms with raised island platforms. The remains of this crossing, closed in the 1950s, are still visible near Ellwood Avenue and Broadway. (Photograph by John Springer.)

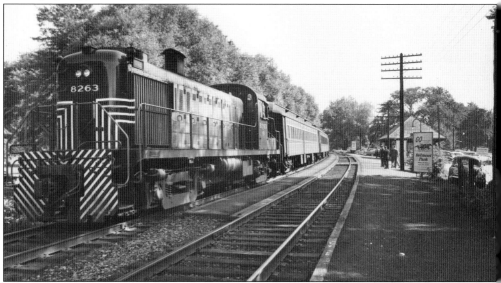

By 1984, due to light traffic, track curvature, and lacking station room, Thornwood was closed during the Upper Harlem Electrification Project. This 1962 photograph shows a morning train led by an ALCO RS-3, one of 135 of this type bought by New York Central in the early 1950s to replace steam. In the New York City region, the RS-3 became the most prevalent locomotive in local freight and diesel passenger service into the late 1960s. (Photograph by Ed Nowak, Courtesy New York Central System Historical Society.)

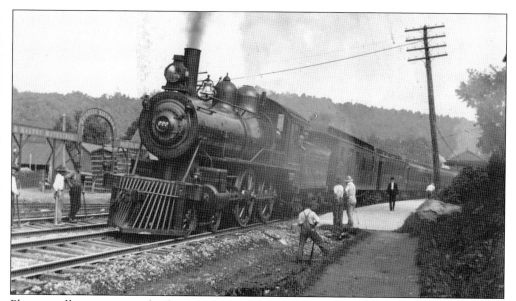

Pleasantville was among the few busy villages in sparser northern Westchester. A small yard served local businesses and the *Reader's Digest* magazine offices behind the two main tracks. The locomotive is the famous 999 of 100-mph speed record fame, built in 1893 in Central's West Albany Shops as a one-of-a-kind 4-4-0 fast passenger engine. It was later rebuilt for more utilitarian service, such as on this commuter job about 1906. It was retired in 1923 and today is in Chicago's Museum of Science and Industry. (Courtesy of Westchester County Historical Society.)

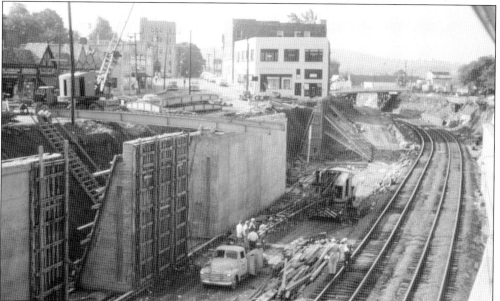

Busy Pleasantville was cursed with two downtown street crossings. Suburban growth by the 1950s warranted elimination of the crossings. The tracks were placed into this trench, and the village, being on a small rise, suffered little impact from the project. Manville and Bedford Roads were free of crossings by 1962. An island platform was built, the upper Harlem Line's first, with the station returned in place. Today's platform was raised for the electrification project. (Courtesy of Westchester County Historical Society.)

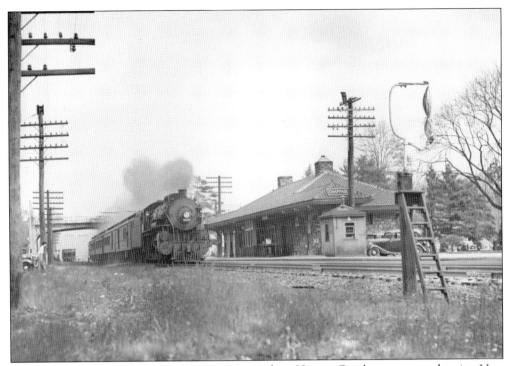

Chappaqua's Quaker origins date to 1730. News editor Horace Greeley was a trendsetting New York passenger who commuted from his farm here in the mid-1800s. The historic 1902 stone station was built on land donated by a Greeley daughter. This 1930s view illustrates picking up mail on the fly. This eastbound New York train was one of several on most county lines, providing local mail service through a railway post office, aiding distribution. (Courtesy of the New York Central System Historical Society.)

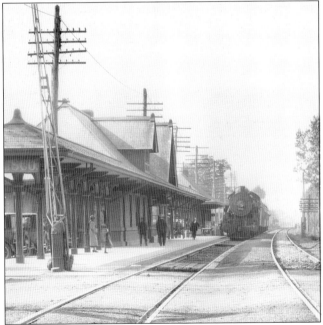

Mount Kisco was incorporated in 1875 and became northeastern Westchester's largest village. The 1910 station style was a later Shepley Rutan and Coolidge design, shown here about 1930. Later, Mount Kisco eliminated its Main Street grade crossing with a highway overpass. During the same period, other busier crossings were closed. The station was a couple hundred feet east and was moved to today's depot. North of the station, freight customers were a propane firm, a lumber company, and a large supermarket warehouse. (Courtesy of the New York Central System Historical Society.)

Schedule of June 6, 1909.

NEW YORK CENTRAL & HUDSON RIVER R. R.

HARLEM DIVISION. WEEK-DAY TRAINS—North-Bound.
(Continued.)

Trains depart from Lexington Ave. Temporary Terminal,
43d Street and Lexington Ave., New York.

For Sunday Trains North-bound see pages 17 and 18.

STATIONS.	Distances	17 Pawling	139 White Plains	P 35 Lake Mahopac	P37 Pawling	143 White Plains	19 Chatham	21 Lake Mahopac	145 Mount Vernon	23 Pawling Local Ex.	147 White Plains	149 White Plains	151 Mount Vernon	153 White Plains	155 Mount Vernon	25 Dover Plains	157 White Plains	159 Mount Vernon	161 White Plains	163 Mount Vernon	27 Brewster	167 White Plains	169 White Plains	29 Brewster	171 White Plains	173 White Plains	175 White Plains	31 Brewster
Lv. New York (Grand Central)		4 05	4 16	4 24		4 43	4 47	5 03	5 05	5 11	5 20	5 23	5 34	5 38	5 54	6 12	6 17	6 26	6 37	6 44	6 53	7 30	8 35	9 03	9 35	10 35	11 35	11 57
" New York (125th Street)	5	4 16	4 26	4 45			4 57	5 13	5 20	5 21		5 44	5 48		6 04		6 28	6 46		6 54	7 04	7 40	8 45	9 14	9 45	10 45	11 45	12 08
" New York (138th Street)	5		4 29			5 00	5 16		5 24				5 51		6 07													
" Melrose (E. 162d Street)—D	7						5 26						5 53									7 43	8 48	9 17	9 48	10 48	11 48	
" Morrisania (E. 168th St.)—D	7												5 55									7 46	8 51		9 51	10 51	11 51	
" Claremont Park (E. 171st St.)—O,D	8																					7 48	8 53		9 53	10 53	11 53	
" Tremont (E. 177th St.)—D	8		4 34																			7 50	8 55		9 55	10 55	11 55	
" 183d Street—C,D	9																					7 52	8 57		9 57	10 57	11 57	
" Fordham (E. 190th St.)—D	9																											
" Botanical Garden (East 200th Street)	10		4 38										6 03					6 44	7 07			7 55	9 00		10 00	11 00	12 00	
" Williams Bridge (East 210th Street)	11		4 40										6 05					6 46	7 09			7 57	9 02		10 02	11 02	12 02	
" Woodlawn (E. 233d Street)	12		4 43						5 48				6 07					6 48	7 11			7 59	9 04		10 04	11 04	12 04	
" Wakefield (E. 242d St.)—C	13		4 44						5 50													8 02	9 06		10 05	11 06	12 06	
" Mount Vernon	14		4 49			5 17			5 55	6 05	6 15	6 25	6 45			6 48	6 56	7 07	7 19	7 24		8 09	9 14	9 35	10 09	11 09	12 14	12 29
" Bronxville	16		4 53			5 22			5 58	6 08						6 53		7 15		7 32		8 17	9 22	9 40	10 19	11 19	12 19	12 34
" Tuckahoe	17		4 55			5 25			6 02	6 12						6 56				7 36		8 20	9 25	9 43	10 25	11 25	12 25	12 36
" Crestwood	17		4 58			5 28			6 04	6 14						6 58		7 18		7 39		8 23	9 28	9 46	10 28	11 28	12 28	12 39
" Scarsdale	19		5 03			5 32			6 08	6 16						7 01		7 22		7 42		8 26	9 31	9 50	10 31	11 31	12 31	12 42
" Hartsdale	21		5 06			5 36			6 16	6 24						7 05		7 25		7 46		8 29	9 34	9 54	10 34	11 34	12 34	12 46
" White Plains	23	4 50	5 12	5 19		5 40	5 47	5 56		6 06	6 20	6 30		6 45			6 58	7 13	7 28	7 48	8 35	9 39	10 00	10 39	11 39	12 39	12 51	
" North White Plains—C	25		5 17			5 44					6 26	6 34		6 55			7 18				8 40	9 44		10 44	11 44	12 44		
" Valhalla	26	4 56			5 32		6 03			6 12																		12 57
" Kensico Cemetery	27	4 58															7 04				7 53			10 06				
" Mt. Pleasant and Fairlawn Cemeteries	28																											
" Hawthorne	29	5 02					6 09			6 18					7 10			7 59				10 12						1 01
" Sherman Park	30	5 05								6 20					7 13			8 02				10 15						1 05
" Pleasantville	31	5 08		5 32			6 14			6 25					7 16			8 05				10 18						1 09
" Chappaqua	33	5 13		5 36						6 30					7 22			8 11				10 24						1 14
" Mount Kisco	37	5 21		5 44	5 49		6 08	6 27		6 38					7 30			8 19				10 32						1 22
" Bedford	40	5 26			5 54			6 35		6 43					7 35							10 37						1 27
Lv. Katonah	42	5 30			5 59			6 40		6 49					7 40			8 24				10 42						1 32
Ar. Golden's Bridge	44	5 36		5 55			6 20	6 41		6 54					7 47			8 34				10 47						1 37
Lv. Golden's Bridge	44			5 57			6 21	6 42							7 47													1 37
Ar. Somer's Centre	47			6 05			6 30	6 50							7 55													1 42
Ar. Lake Mahopac	51			6 13			6 40	7 00							8 05													
Lv. Somer's Centre	0								5 38						7 20													
Lv. Somer's Centre	4								5 50						7 30													
Ar. Golden's Bridge	8								5 55						7 39													
Lv. Golden's Bridge	44	5 36					6 20		6 54						7 45			8 34				10 47						1 37
" Purdy's	47	5 41							6 59						7 51			8 39				10 52						1 42
" Croton Falls	48	5 46		6 09					7 04						7 56			8 43				10 56						1 46
" Brewster	52	5 56		6 18		6 33			7 14						8 06			8 53				11 05						1 55
" Dykeman's	55	6 00							7 20						8 11													
" Towner's	58	6 05							7 23						8 14													
" Patterson	61	6 14			6 31				7 30						8 22													
" Pawling	64	6 22			6 37		7 00		7 43			7 40			8 31													
" Wingdale	70						7 10					7 46																
" Dover Furnace	73						7 19																					
" Dover Plains	77						7 25																					
" Wassaic	82						7 35																					
" Amenia	85						7 36					7 46																
" Sharon Station	88						7 42																					
" Coleman's	90						7 44					6 52																
" Millerton	93						7 52																					
" Mount Riga	96						7 59																					
" Boston Corners	100						8 07																					
" Copake	105						8 15																					
" Hillsdale	108						8 22																					
" Craryville	112						8 27																					
" Martindale	116						8 33																					
" Philmont	119						8 39																					
Lv. Ghent	125						8 48																					
Ar. Chatham	128						8 53																					

Column notes (printed vertically): P 35 — "FIRST TRIP JUNE 21"; "DOES NOT RUN ON SATURDAY" (P37); "DOES NOT RUN ON SATURDAY" (143); and "WILL NOT CARRY BAGGAGE" in trains 145, 23, 147, 149, 151, 153, 155, 157, 159, 161, 163, 167, 169, 171, 173, 175.

f—Stops on signal to discharge or receive passengers.
C—Baggage cannot be handled at 183d St., Claremont Park, Wakefield or North White Plains, and should therefore be forwarded to the most convenient station north or south of those points.
D—The door will close one minute before schedule time for the departure of all trains.
G—Train No. 19 will not handle baggage at Mt. Riga.
P—Has parlor car attached.
T—Stops at 125th St. or 138th St. only to receive passengers.
V—Stops on signal only to receive passengers.
X—Stops to discharge passengers only.

11 12

This evening schedule panel is from about when some early electric service was being phased in. While trains beyond here likely changed power, it was only later that the not-shown Harlem Avenue platform was added for passengers. Mount Vernon still kept a small terminal. Upper Westchester enjoyed frequent service. Train 19, departing GCT at 5:03 p.m. to Chatham, was among five daily trains departing in a three-hour pattern that ran until the Great Depression service shakeout and cutbacks of the 1930s. Note the frequent Lake Mahopac service via Goldens Bridge. (Courtesy of J.W. Swanberg.)

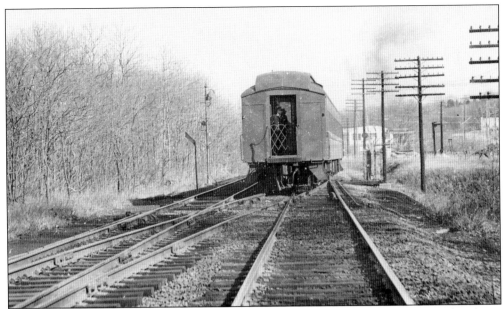

The upper Harlem line, seen in pre-electrification days, retained the feel of a quaint railroad into the 1980s. Bedford Hills Crossover was among seven crossover points spaced between Mount Pleasant and Croton Falls. These manually operated switches were generally manned by telegrapher-operators, or sometimes "towermen" and used for rerouting during closures, emergencies, or regular maintenance requiring single-track operation over a given portion of the railroad. These were later replaced by remote control points. (Courtesy of John Springer.)

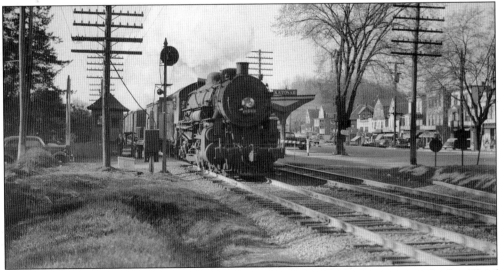

Katonah, a hamlet within the town of Bedford, was named after area native leader Chief Katonah, with Delaware, Wappinger, and Algonquin connections and whose Mohegan tribal area encompassed parts of the northeastern county and neighboring Connecticut. Katonah is associated with Martha Stewart but was also home to John Jay, statesman and negotiator of the post-revolutionary peace treaty with Britain. This westbound local freight heading to Brewster is crossing Jay Street in the 1940s. (Courtesy of the Westchester County Historical Society.)

Goldens Bridge, within Lewisboro, was first surveyed in 1750. This 1967 photograph shows remnants of the Goldens Bridge junction accessing the Mahopac Branch linking up with the Putnam division at the south end of Lake Mahopac's yard and station. Its branch line passenger service, fading since the Depression, ended in 1959. The crossover seen here next to a telegraphy cabin led to a yard that was mostly rusted by the 1960s. King Lumber, which trucks in lumber today, was the final freight customer here in the 1990s. (Photograph by John Springer.)

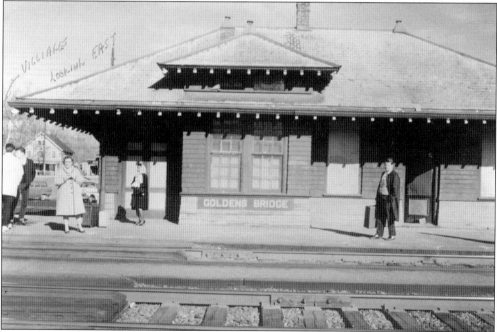

Construction of Interstate 684 in 1969 marked Goldens Bridge depot's demolition: without a station agent since 1959, about when this photograph was taken, part of the hamlet, which once was a small magnet for commerce in the area, included nearby Connecticut farms. Goldens Bridge became home to the 1935 Goldens Bridge Colony. Highway construction also altered or removed the towns or station centers at Purdys, Ardsley, Croton-on-Hudson, Larchmont, and Rye. (Courtesy of the Westchester County Historical Society)

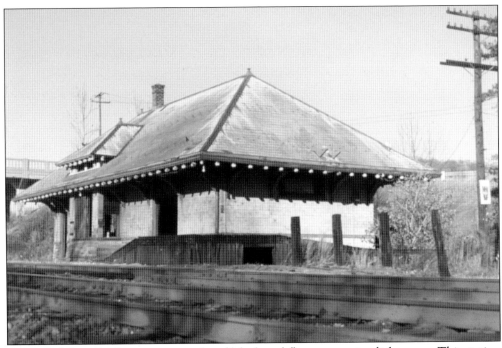

In North Salem, Purdys was among a handful of rural flag stops seeing light usage. This station almost closed in 1955, but descendants of Isaac Purdy presented New York Central with an 1840s legal agreement stating that the land given to the New York & Harlem was contingent upon train service; thus, the stop was saved. When photographed in 1973, Purdys was in disrepair under Penn Central and had about eight weekday trains and little weekend service. (Photograph by Kent Patterson, courtesy of the North Salem Historical Society.)

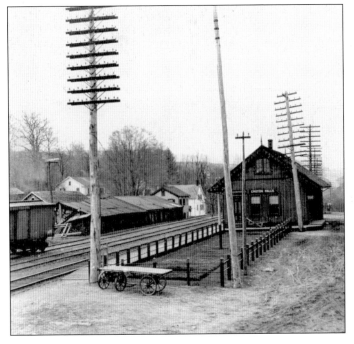

North Salem is a two-station town when adding Croton Falls, Westchester's northernmost station on the Harlem line. Between 1847 and 1849, it served as the terminus due to the resistant stone terrain. It is believed that the two Revolutionary War militiamen who captured British spy Maj. John André in Tarrytown traveled from North Salem. It has a town hall dating to 1777, and the sparse area has a remote New England look; North Salem is also a big player in the county's equestrian world. (Courtesy collection North Salem Historical Society.)

This 1907 photograph in Croton Falls shows a proud crew with their Alco-Schenectady 4-4-2 Atlantic type and one of 200 I-Class passenger engines, nicknamed Gibson Girls. This wheel arrangement was a step up from the very prevalent 4-4-0 American type; these high-waisted locomotives were soon obsolesced by bigger and more powerful locomotives. Unfortunately, the 4-4-2 Atlantic's day was brief, since heavier 4-6-0 ten-wheelers and even the more robust 4-6-2 Pacific types answered calls for faster locomotives that could easily haul a dozen steel Pullman cars. (Courtesy of the North Salem Historical Society.)

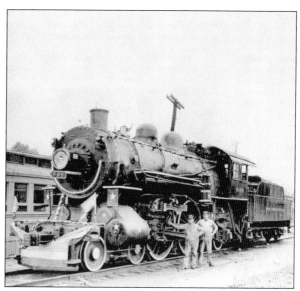

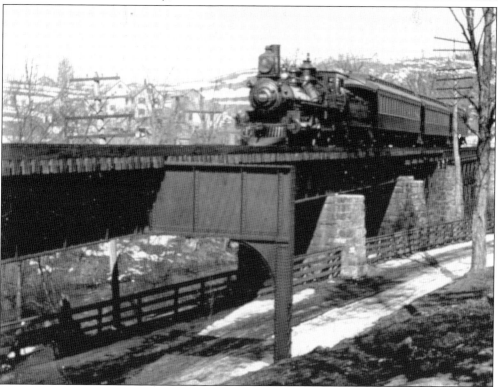

This photograph, taken near the Westchester-Putnam County border, shows American-type engine 965 crossing this still-used steel bridge designed to navigate this complicated area of uncooperative granite, the Croton River, Route 22, and the start of a grade toward Brewster. By 1900, most of these 4-4-0 types stopped being manufactured, but some worked through the 1920s, with a few survivors of later 4-4-0 classes surviving into the 1950s on mundane assignments. This wheel arrangement reigned on American tracks for over half a century, starring in Western movies, and often being pampered by crews. (Courtesy of the North Salem Historical Society.)

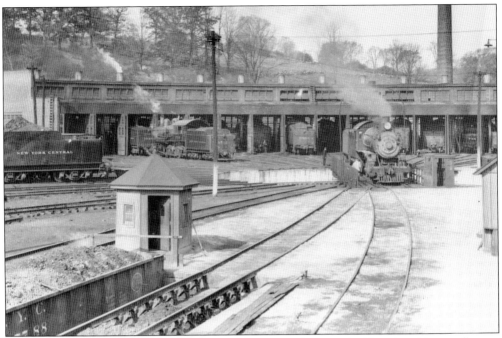

A mile above the Brewster station was Putnam Junction, a key terminal housing this roundhouse, a coach yard, and small freight yard supporting much of upper Westchester's rail needs. Both the Harlem and Putnam lines originated or terminated trains here. Judging by the pre-Gothic lettering of about a dozen locomotives, this photograph dates to the 1920s or 1930s. (Courtesy of the New York Central System Historical Society.)

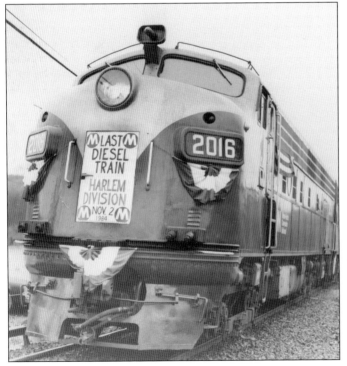

The year 1984 marked the Upper Harlem line's electrification, with the final diesel train to GCT seen here in November. Faster, more reliable service helped transition northeast Westchester and adjacent Putnam County toward a more suburban complexion, versus its now fading rural character. Herein, the Harlem line and its rural towns went from being served by a sleepy, old, sometimes-unreliable branch line–type railroad hauling considerable passenger traffic, to a faster, more reliable big-city operation whose cosmopolitan feel influenced prospering villages. (Photograph by J.W. Swanberg.)

Three

THE HUDSON LINE

The New York Central System, generally dubbed "the Central," operated its east-west system through 10 states and two Canadian provinces. Central's Hudson division handled most of the system's freight, long-haul passengers, mail, express, livestock, and dairy destined for Manhattan. It was also the most consistently profitable railroad in Westchester through the 1960s. The Hudson line never had voluminous commuter business like Central's Harlem division or the New Haven Railroad, yet this artery merited a four-track operation.

The Hudson line, completed in 1851, was the independent Hudson River Railroad until the late 1860s, when Vanderbilt acquired the upstate New York Central Railroad from Albany to Buffalo and then integrated his Harlem and Hudson line, along with his spindly Putnam Railroad, into a single empire, consolidating in phases through the 1920s.

For Westchester, even New York City, Vanderbilt addressed urban growth and congestion with better transportation. His building of Grand Central, completed in 1871, replaced the prior Hudson Railroad Terminus in western Manhattan and a prior primitive midtown depot. He was ridiculed for building at the edge of the city at that time, but he set the stage for a big future midtown, as Harlem, Hudson, and slightly later, the New Haven Railroad gravitated to this new hub. The initial Hudson River Railroad on the west side did remain as Central's main freight line.

Westchester, lying in the path of numerous transport arteries, enjoyed the amenity of faster freight service, a generous suburban passenger service, and fine passenger train access west from Croton-Harmon. A lesser level of long-haul trains called at Yonkers and Peekskill. Connections could be made via suburban service from the local stations on all lines.

Local freight customers included Domino Sugar, Phelps Dodge Cable, and Otis Elevator in Yonkers, Anaconda Copper in Hastings, General Motors in Tarrytown, and the Fleishmans Distillery in Peekskill. Like the Harlem division, most stations handled local freight customers of coal, lumber, foodstuffs, or general merchandise. Some freight passing through the county was transshipped overseas.

New York Central System turned consistent profits, even with the railroad's financial headwinds strengthening in the 1960s. Then-president Alfred E. Perlman took a scalpel to money-losing services, resulting in a smaller system. Worse, Central merged into an unpruned, less modern, and financially weaker Pennsylvania Railroad in February 1968.

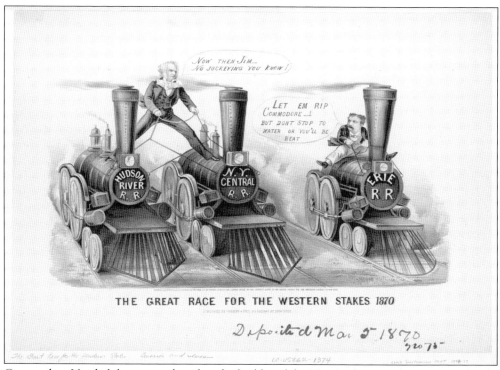

Commodore Vanderbilt is remembered as the builder of the New York Central empire. He fought competitors in love-hate relationships. This cartoon depicts Vanderbilt battling James Fisk for the Erie Railroad: Fisk won. The Erie, a less prosperous competitor, built its first terminal at Piermont within telescope view of another Erie backer, Jay Gould's Lyndhurst Estate in Tarrytown. Some early rail planners in southwest New England looked to Erie access as an alternate to Vanderbilt's railroads, which were approaching monopoly status. (Courtesy of the Library of Congress.)

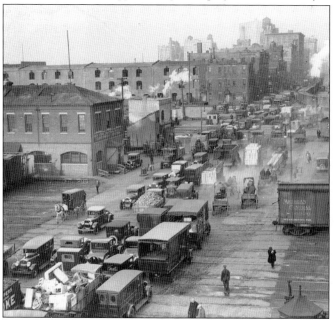

The Hudson River Railroad first ran straight down the Hudson line to West Thirtieth Street, adjacent to the Hudson River. This 1920s Eleventh Avenue view shows that while Grand Central Terminal's locale was 50-plus years old, freight traffic to factories, slaughterhouses, tanneries, and produce houses kept this line very busy in a place called Hell's Kitchen. Freight was also floated by Central's two dozen tugboats, plus rail barges, to over a half-dozen railheads across the river in New Jersey. (Courtesy of the New York Central System Historical Society.)

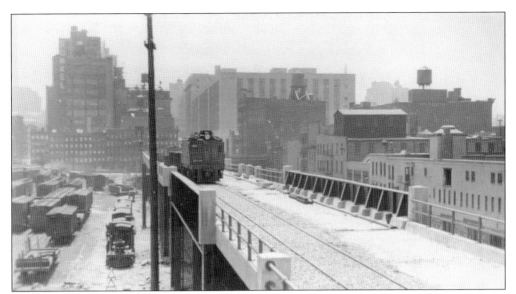

By 1931, the former Hudson River Railroad trackage was by now the Thirtieth Street Branch. Above Thirtieth Street, tracks were placed below street level in a mostly covered trench. Below Thirtieth Street, trackage was elevated running to St. Johns Park. Parts of these elevated tracks form today's famous High Line. This view is near the elevated portion's start, with the Thirtieth Street freight yard at left. After a 1983 abandonment, in 1992 it was reopened above Thirty-Third Street to access Amtrak's Pennsylvania Station. (Courtesy of the New York Central System Historical Society.)

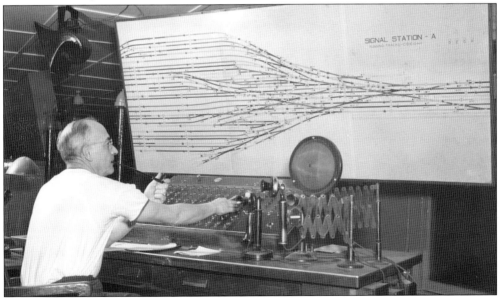

New York Central Hudson and Harlem divisions, plus tenant New Haven Railroad, terminated trains in Grand Central Terminal, where, in this 1950s view, Tower A's director manages upper-level train movement by referencing the track chart. Most of the upper-level track arrangement is similar today, minus a handful of tracks. Terminal trackage shown here spans roughly from Forty-Fourth Street to Fifty-Sixth Street, where the next interlocking point, Tower U, sorts trains to the upper and lower levels. (Courtesy of the New York Central System Historical Society.)

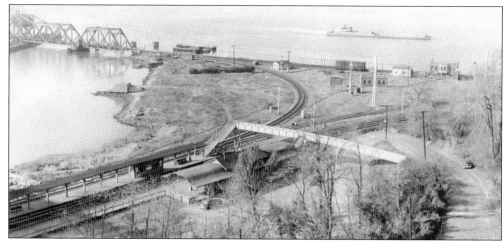

This image, captured 10 miles from Grand Central, shows Spuyten Duyvil station in Riverdale, with the Hudson River in the distance. The foreground trackage marked the start of Vanderbilt's acquired Spuyten Duyvil & Port Morris Railroad, built in 1870 to access the Hudson Railroad at Mott Haven, allowing routing to the under-construction Grand Central Station. In 1913, during the construction of Grand Central, many enhancements to increase operational capacity and flexibility were required well north of the terminal to support its vast traffic flow. (Courtesy of the New York Central System Historical Society.)

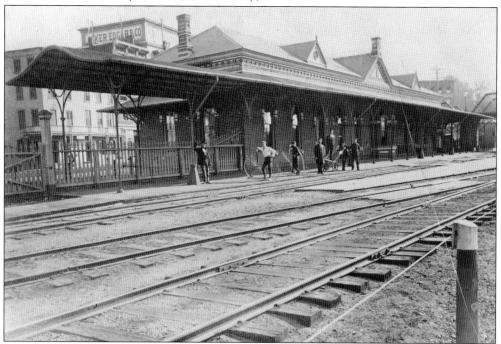

Yonkers station was street level in the 1890s. In 1911, the line was grade separated and given its current city style, Beaux-Arts station, designed by Warren & Wetmore. Yonkers, the state's fourth largest city, was first incorporated as a town in 1788, getting partial train service by 1849. Part of south Yonkers was annexed into Bronx County when it joined New York City in 1898. Once called the "City of Gracious Living," its original Dutch name was Jonkers. (Courtesy of the New York Central System Historical Society.)

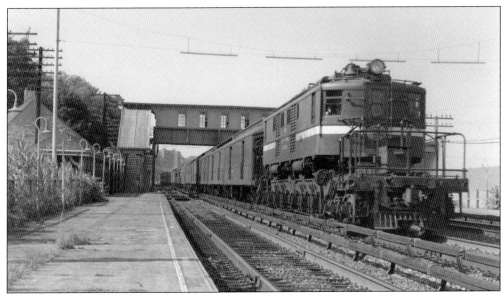

Greystone station, in northern Yonkers, was built in 1899 by Charles Harriman, a developer. Greystone was a spy dead-drop during the 1950s. This image shows a 1965 Empire State Express bound for Buffalo and beyond with 16 cars. The electric locomotive, a 1929 ALCO/GE P-2, was made to haul trains into the electric zone under Cleveland Union Terminal. The motors were reassigned to Harmon in 1955. The box-cab design was laid down atop a powerful motor and 20 wheels. A diesel locomotive would later take over beyond Croton-Harmon. (Photograph by Richard Herbert.)

Hastings on Hudson is the northernmost point across from the Hudson River's palisades, as seen in this idyllic 1940s Leslie Ragan painting advertising the new 1941 streamlined Empire State Express; it was one of many art commissions done for the Central. Portions of this curvy river-shore railroad needed straightening for better speed and an easier ride. When Grand Central was being excavated for its two-levels-deep operation, the bedrock of schist was sent north and used as fill for right-of-way enhancements. (Courtesy of the New York Central System Historical Society.)

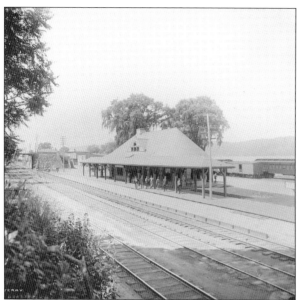

This 1889 image of Dobbs Ferry's station prior to electrification shows a new Richardsonian Romanesque–style depot by architectural firm Shepley, Rutan and Coolidge, which frequently contracted with New York Central throughout the system. Many additional depot examples are at Tarrytown, Garrison, and Chatham, and at Palmer, Massachusetts, and Kalamazoo, Michigan. As Dobbs Ferry grew, it incorporated in 1882 with about 2,000 residents. Like numerous villages on the Hudson River, the main village, homes, and estates were up the hill from the Hudson line, providing a feeling of solitude at most river stations. (Courtesy of the Library of Congress.)

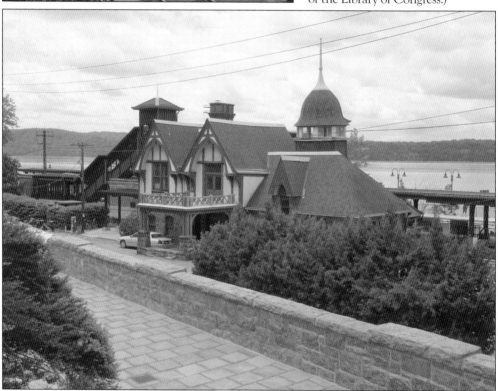

Irvington's second station just south of its main station is its 1890s Ardsley-on-Hudson station. It was of unique design and built with funds from Gould, Morgan, and a Vanderbilt descendant. Over the years, this unique station was an access to a casino, country club, swim and tennis club, and luxury apartment building, which is its use today. An active post office is still in use. Irvington's principal village station was a smaller example of Shepley, Rutan and Coolidge architecture. (Author's collection.)

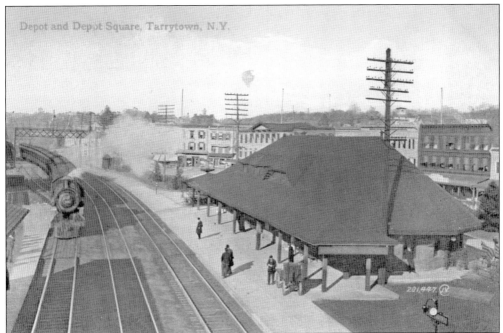

Depot and Depot Square, Tarrytown, N.Y.

Tarrytown was among the more urban river towns, where Dutch settling began in 1645. The postcard shows the landmark 1890 Richardson Romanesque–inspired station before electrification. For a brief period during early electrification, this was the northern terminus for Hudson electric service, prior to Croton-Harmon's completion. Nearby was North Tarrytown's General Motors plant that built Chevrolets, operating from 1896 to 1996; it was initially a Stanley steam car factory before becoming a Chevrolet plant and principal shipper in 1918. (Author's collection.)

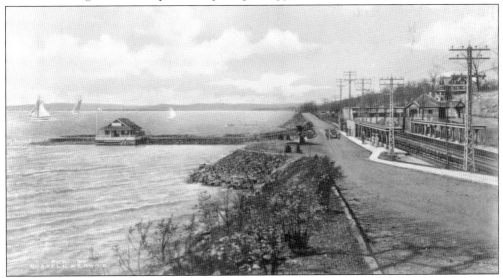

North Tarrytown, renamed Sleepy Hollow in 1998, was served by Philipse Manor station. Before the British seized the New Amsterdam Dutch colony, the family name was Van Phelps. Quickly assimilating into British society, the wealthy farmer and miller anglicized his name. John D. Rockefeller built his estate two miles up the hill in Pocantico Hills. (Courtesy of the New York Central System Historical Society.)

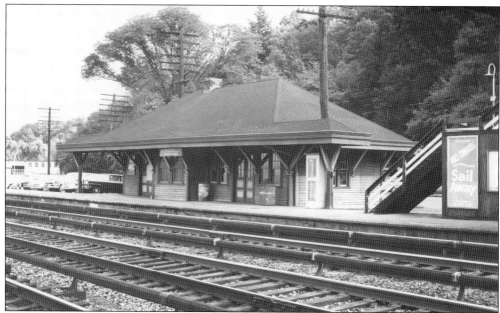

Scarborough Station's 1899 wooden depot is now a post office, and within the village of Briarcliff, and the town of Ossining. A rebuilt MTA Metro-North station is just north. Scarborough is a good example of filled-in land at numerous area stations. Fill was used to complete rail sections near coves, bays, and marsh. Additional fill eventually was placed along the river near stations for yards, docks, industry, straightening rights of ways, and parking lots. (Courtesy of the New York Central System Historical Society.)

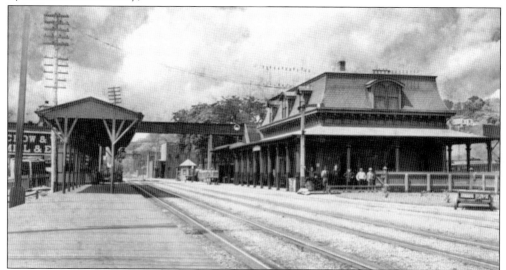

The pre-1914 Ossining station, before today's depot and street, was built above the newly electrified tracks. Originally called Sing Sing, a name of Algonquin origin, Ossining took this name in 1901 to differentiate it from the prison. The village today has 25,000 residents and is a significant river town. It was home to the Brandreth Vegetable Pill factory, Havahart Traps, and several boat builders. Today, a weekday commuter ferry to Haverstraw is the county's sole ferry service. Ossining was the home of actors Peter Falk, Howard Desilva, and John Cheever, and journalist John Batchelor. (Courtesy of the Ossining Historical Society Museum.)

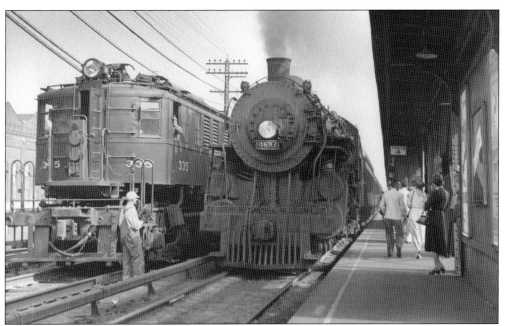

Croton-Harmon is home to Westchester's largest rail facility, servicing both steam and electric by 1913 in part to support a new Grand Central Terminal, which needed an electric fleet. For many, it was simply called Harmon, where the electric trains switched over to steam locomotives and, in later years, to diesel to haul trains west. Beside this 4-6-2 Pacific-type steam engine is an R-2 electric locomotive around 1947. About 80 various electric motors were maintained here, along with service for an even larger number of steam and diesel locomotives. (Courtesy of J.W. Swanberg)

This aerial view from about 1961 shows the drive-in theater and a pre-expressway US Route 9 in a more desolate Croton-Harmon. Note the canals in Croton Point, replaced since by a now-closed dump. Steam facilities are visible, all of which were demolished over the ensuing decade. The electric shop shown is being replaced today. Other changes include a huge parking lot, Halfmoon Bay Condos, and a shopping center over the former drive-in site. (Courtesy of the Westchester County Historical Society.)

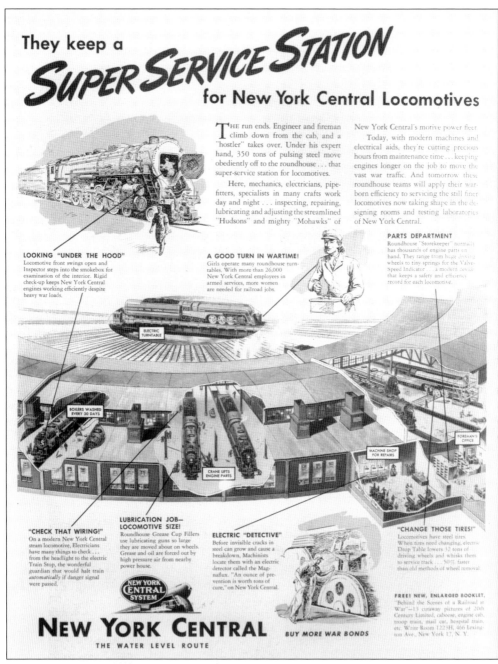

They keep a

Super Service Station

for New York Central Locomotives

THE run ends. Engineer and fireman climb down from the cab, and a "hostler" takes over. Under his expert hand, 350 tons of pulsing steel move obediently off to the roundhouse... that super-service station for locomotives.

Here, mechanics, electricians, pipefitters, specialists in many crafts work day and night... inspecting, repairing, lubricating and adjusting the streamlined "Hudsons" and mighty "Mohawks" of New York Central's motive power fleet.

Today, with modern machines and electrical aids, they're cutting precious hours from maintenance time... keeping engines longer on the job to move the vast war traffic. And tomorrow these roundhouse teams will apply their war-born efficiency to servicing the still finer locomotives now taking shape in the designing rooms and testing laboratories of New York Central.

PARTS DEPARTMENT
Roundhouse "Storekeeper" normally has thousands of engine parts on hand. They range from huge driving wheels to tiny springs for the Valve-Speed Indicator... a modern device that keeps a safety and efficiency record for each locomotive.

LOOKING "UNDER THE HOOD"
Locomotive front swings open and Inspector steps into the smokebox for examination of the interior. Rigid check-up keeps New York Central engines working efficiently despite heavy war loads.

A GOOD TURN IN WARTIME!
Girls operate many roundhouse turntables. With more than 26,000 New York Central employees in armed services, more women are needed for railroad jobs.

"CHECK THAT WIRING!"
On a modern New York Central steam locomotive, Electricians have many things to check... from the headlight to the electric Train Stop, the wonderful guardian that would halt train *automatically* if danger signal were passed.

LUBRICATION JOB—LOCOMOTIVE SIZE!
Roundhouse Grease Cup Fillers use lubricating guns so large they are moved about on wheels. Grease and oil are forced out by high pressure air from nearby power house.

ELECTRIC "DETECTIVE"
Before invisible cracks in steel can grow and cause a breakdown, Machinists locate them with an electric detector called the Magnaflux. "An ounce of prevention is worth tons of cure," on New York Central.

"CHANGE THOSE TIRES!"
Locomotives have steel tires. When tires need changing, electric Drop Table lowers 32 tons of driving wheels and whisks them to service track... 50% faster than old methods of wheel removal.

NEW YORK CENTRAL
THE WATER LEVEL ROUTE

FREE! NEW, ENLARGED BOOKLET, "Behind the Scenes of a Railroad at War"—13 cutaway pictures of 20th Century Limited, caboose, engine cab, troop train, mail car, hospital train, etc. Write Room 1225H, 466 Lexington Ave., New York 17, N. Y.

This World War II–era advertisement depicts Harmon's roundhouse and servicing of its locomotives. The illustration shows the latest motive power being maintained. The war strained all railroads, causing much wear of all rolling stock. Although railroads earned good revenue, maintenance was partly deferred. This would affect most all railroads' infrastructure for years after the war worldwide. (Courtesy of the New York Central System Historical Society.)

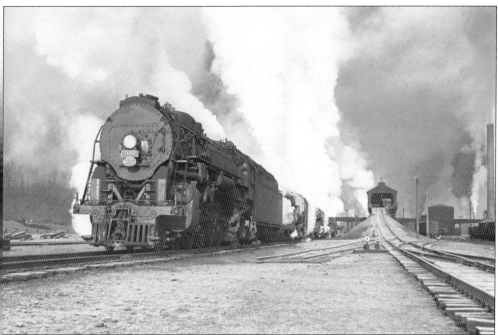

In addition to meeting passenger needs, Harmon serviced, watered, and coaled these freight haulers that swapped locomotive power to electric here. The above photograph shows two examples of L-Series 4-8-2 Mohawks. In total, 600 were built by Alco. The photograph below shows a passenger-purposed J-3 Hudson Type 5441 parked behind a Mohawk 3018. Both engine types had similar boilers and were of similar weight. The engines shown were recently outfitted with newer PT type tenders with a larger coal bunker, adding range to Central's locomotives. (Both, courtesy of the New York Central System Historical Society.)

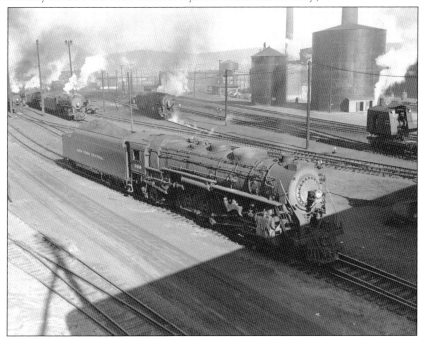

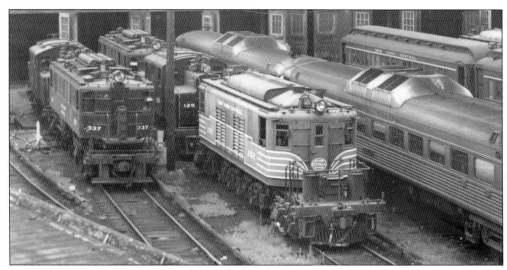

Pictured is Croton-Harmon's diesel and electric shops around 1964. The equipment includes, from left to right, five various vintage electric locomotives, a pair of Rail Diesel Cars (the newest equipment shown here), and two 1920s MU cars. Most of the electric locomotives and MU cars would be phased out within the decade. (Photograph by J.W. Swanberg.)

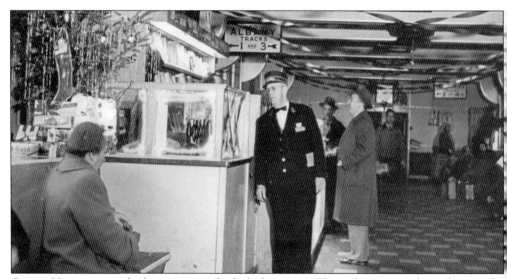

Croton-Harmon never had an ornate cathedral of a station. The earlier station shown here in the late 1950s was a mundane building atop a bridge over the tracks adjacent to the Croton Avenue bridge, faintly similar to the current station. This photograph shows a basic but cozy and friendly station, with Christmas decorations put up by station staffers, and a concession stand. One station master, Dell Blank, was a celebrity of sorts among passengers, employees, and even taxi drivers. (Courtesy of the Croton-on-Hudson Historical Society.)

CONDENSED TIME TABLE
NEW YORK, ALBANY and BOSTON to BUFFALO, HAMILTON, TORONTO, CLEVELAND, TOLEDO, DETROIT and CHICAGO

The time shown is Eastern Standard Time Toledo, Niles and east and Central Standard Time at stations west thereof

Table No. 2

	Adv. Empire State Exp.	Empire State Express	The Mohawk	North Shore Limited	Advance Knickerbocker	The Knickerbocker	The Pacemaker	Advance Commodore Vanderbilt	The Comm. Vanderbilt	Ohio State Limited	The New England States	20th Century Limited	The Wolverine	New England Wolverine	Lake Shore Limited	The Detroiter	Southwestern Limited	Cleveland Limited	The North Star	Niagara	The Chicagoan	The Iroquois	The Michigan	The Chicagoan	The Genesee	The Cayuga	The Tuscarora	South Shore Express	
	55	51	5	39	49	41	1	65	15	67	27	25	17	33-17	33-19	19	47	11	57	21	29	59	35	35-35	59-35	81-335	83	99	163-43-45
	D'ly	Daily	D'ly	Daily	D'ly	D'ly	Daily	Daily	Daily	D'ly	D'ly	D'ly	Daily	Daily Ex. Sat.	Daily Ex. Sat.	Daily	Daily Ex. Sat.	Daily	D'ly	Daily	D'ly	D'ly	D'ly	Daily	Daily	Sat. Only	Sat. Ex.	Sat. Ex.	Daily

(This is a dense multi-train condensed railroad timetable. The body of the table lists station stops — New York (Grand Central Terminal), New York (125th St.), Yonkers, Harmon, Poughkeepsie, Albany; Boston (So. Station), Trinity Place, Newtonville, Framingham, Worcester, Springfield, Pittsfield, Chatham, Albany; Albany, Schenectady, Utica, Rome, Syracuse, Rochester, Buffalo; T.H. & B.-C.P. Rys.: Buffalo, Welland, Hamilton, Sunnyside, Toronto (Union Sta.); Buffalo, Niagara Falls, St. Thomas, London, Windsor, Detroit; Detroit, Saginaw, Bay City, Mackinaw City; Detroit, Ann Arbor, Jackson, Grand Rapids, Albion, Battle Creek, Kalamazoo, Niles, Michigan City, Gary, Hammond, Woodlawn (63rd St.), Chicago (Cent. Sta.); Buffalo, Dunkirk, Westfield, Erie, Ashtabula, East Cleveland, Cleveland (Un. Term.); Cleveland, Linndale, Elyria, Sandusky, Toledo, Elkhart, South Bend, Gary, Englewood, Chicago (La Salle Street Station) — with departure/arrival times in each train's column.)

This steam-era 1952 New York–Chicago condensed schedule shows over 20 westbound trains headed to upstate, the Midwest, or Canada. Croton-Harmon station—then simply called Harmon, in the Village of Croton-on-Hudson—required that all trains stop there to swap locomotives from steam (later diesel) to electric locomotive haulage to/from New York City. County residents mostly relied on the local suburban trains originating at Harmon, Croton's north station, or the few trains from Poughkeepsie or Peekskill. Yonkers also enjoyed good long-distance service with about half of the trains seen here calling there. (Courtesy of the Empire State Passengers Association.)

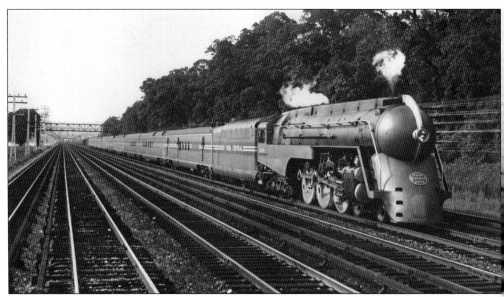

The county hosted several famous trains, notably the *20th Century Limited*, inaugurated in 1902 with a 20-hour New York–Chicago schedule. Often called "the *Century*," it was re-equipped periodically with new equipment. De-assigned equipment trickled to other luxury trains and eventually secondary trains. This 1938 publicity photograph taken between Croton-Harmon and Ossining showcases a new streamlined version inspired by designer Henry Dreyfuss. Ten Hudson-type locomotives were streamlined for *Century* assignment as part of a 1937 purchase of 50 Hudson locomotives—a historic first engine purchase since the start of the Great Depression. (Courtesy of the New York Central System Historical Society.)

The all-Pullman 1950s *Century* was a clubby conveyance. Diner menu items included shrimp cocktail Lorenzo, beluga caviar, eastern halibut with shrimp and seafood sauce, lamb chops with bacon, plum pudding, holiday turkey, potatoes persillade, mince cobbler, puree Jackson with leeks (a fancy pea soup), or a simple omelet. The train also featured very social lounges, a barber, a stenographer, and a registered nurse. The faster 1948 diesel version made this 971-mile run in 16 hours. (Courtesy of the New York Central System Historical Society.)

The *Century* hosted celebrities passing through the county headed back and forth to Hollywood, California. *Century* passengers often continued via the Santa Fe Railway's *Super Chief* west of Chicago and sometimes the Union Pacific or occasionally a Rock Island/Southern Pacific connection. Seen above in the late 1920s is Gloria Swanson. Among other celebrities passing through were Laurel & Hardy, the Three Stooges, Ronald Reagan, Ginger Rogers, Mamie Eisenhower, and Winston Churchill—seen at right, using this train of choice. Alfred Hitchcock, Eva Marie Saint, and Cary Grant, with crew and cast for the movie *North by Northwest*, filmed aboard this train in 1958. People who were not famous, including some rail employees, would save and then splurge for the *Century* experience. A Pennsylvania Railroad counterpart, the *Broadway Limited*, was competitive but never quite gained the *Century's* celebrity popularity. The *20th Century Limited*, considered a world-class train, ran until 1967 and was then replaced by a more basic train. (Both, courtesy of the New York Central System Historical Society.)

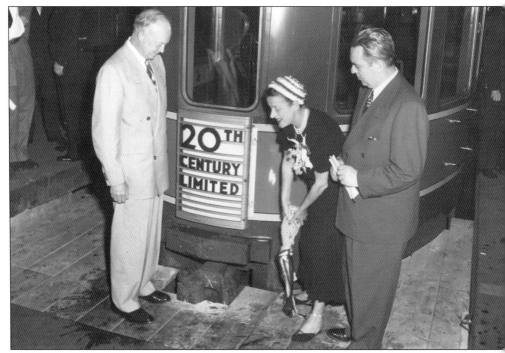

Dwight and Mamie Eisenhower presided at the *20th Century Limited* re-equipping ceremonies in 1948. At this time, General Eisenhower was president of Columbia University. The displaced *Century* consist, not a decade old, was still sound and went to the alternate luxury Chicago train, the *Commodore Vanderbilt*. These were the golden years of streamliners but on the eve of highways and airlines eroding passenger business, leading to a protracted decline in the rail passenger industry. (Courtesy of the New York Central System Historical Society.)

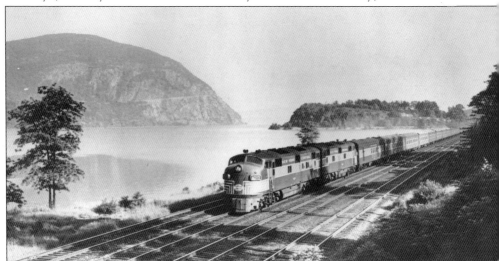

This noted publicity photograph, taken in Putnam County's Cold Spring, shows the 1948 postwar *20th Century Limited* in the northern Hudson Highlands opposite Storm King Mountain, with the latest diesel power and Pullman consist. This train was one of many re-equipped with modern equipment as part of a massive postwar passenger car and locomotive purchase. The locomotives are new General Motors EMD E-7s. (Courtesy of the New York Central System Historical Society.)

This final view at the *Century* looks west at Roa Hook, west of Peekskill, nearing Putnam County and Bear Mountain on its southern approach to the Hudson Highlands in the distance. This route and scenery can still be enjoyed via the MTA Metro-North Railroad, upstate via Amtrak, or beyond to Montreal, Toronto, or Chicago. (Courtesy of the New York Central System Historical Society.)

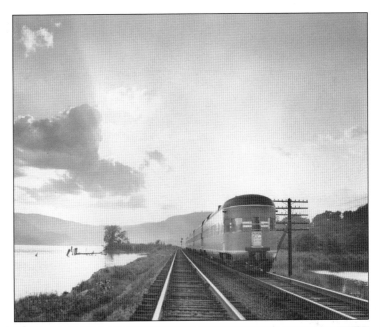

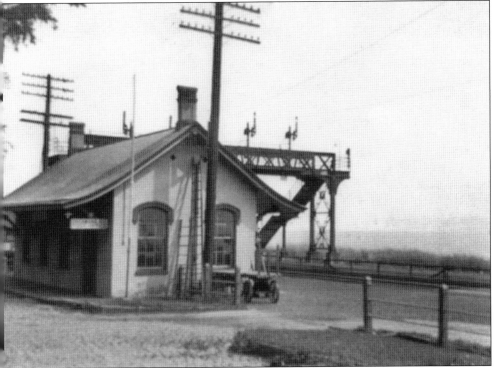

Oscawana station, above Croton, closed in 1973. The depot was a rare example of the earlier brick Hudson River Railroad stations. Typical of northern Westchester then, most saw light use. Oscawana, Crugers, and Montrose stations were in desolate locations and have since been consolidated to today's Cortlandt Manor station. The Hudson Line, as the famed Water Level Route, encountered a respectable grade just north in the Cortlandt Manor area. (Courtesy of the Croton-on-Hudson Historical Society.)

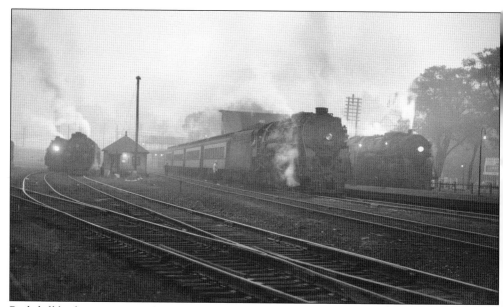

Peekskill had a terminus with a yard and small roundhouse almost from this railroad's beginning until the end of steam. This 1940s night view shows an eastbound train in the station at right, with some morning commuter trains laying over. Peekskill was Westchester's northernmost Hudson line station. Dieselization allowed the railroad to close many satellite terminals like the one seen here, converting toward simpler shuttle trains using self-propelled RDC cars, which terminated here into the 1980s. (Courtesy of the New York Central System Historical Society.)

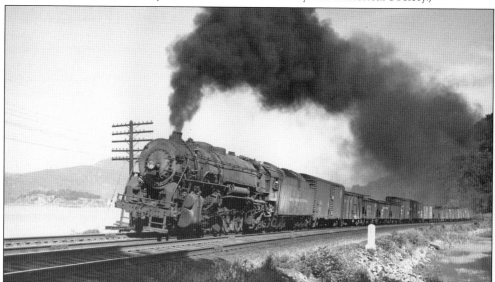

An eastbound freight is seen here in the 1940s in the Hudson Highlands, which spanned from Cortlandt Manor through Putnam County. In this location, near Revolutionary War redoubts at Ft. Montgomery, geographic limitations required the generally four-track railroad to narrow into two between Peekskill and Manitou. Iona Island is visible across the river. This was just one example of the score of freights that traveled here. Aside from heavy passenger traffic, add in mail, express, and about a half dozen milk trains. This image was captured during the pre-highway days. (Courtesy of the New York Central System Historical Society.)

Four

THE NEW HAVEN LINE

Several years after the New York & Harlem line first crossed the Harlem River heading north, 1840s New England investors were building a network of small railroads linking up much of southern New England. Lines tended to be seaport-inland or basic inland routes with the purpose of accessing connections with other carriers. The New England–owned New York & New Haven Railroad, chartered in 1844, was building southwest to New York.

Only 19 miles of the New Haven, as it is often called, pass through Westchester from the Connecticut state line at Port Chester to south of today's Westchester-Bronx city line. These 19 miles eventually became the New Haven's busiest. The eight thriving communities maintained strong commuter patronage. Some early communities date to the 1600s as English, Dutch, and even French settlements. While agriculture was the county's prevalent industry, the shore settlements also had a fishing industry.

In the decades after the 1840s, this would become the key New York–to–New England commerce corridor, accelerating residential and business growth in southeastern Westchester.

The railroad further prospered and grew through a series of mergers with other New England–owned railroads, eventually gaining its long-held formal name, New York, New Haven & Hartford Railroad, becoming the dominant transportation corporation in New England and a near monopoly under J.P. Morgan by 1890.

Until its later years, the New Haven's busy passenger, mail, and freight traffic sustained it, even while stricken at times with financial scandals such as construction and stock fraud and skimmed funds at the healthy railroad's expense. Robert Schuyler in the 1860s and Patrick B. McGinnis in the 1950s were the notables. Other misfortunes were Morgan's propensity to acquire too many transportation companies. The Great Depression became yet another factor, pushing the company into a decade-long bankruptcy in 1935.

By 1961, a proud but financially precarious New Haven again operated in receivership bankruptcy, now losing freight business to trucking. Passenger and commuter business, though still strong, was slow in numerous corridors. Mail and express traffic were starting to abandon rail use too. Another railroad, Penn Central Company, the merged New York Central and Pennsylvania Railroads, was ordered to take over the New Haven's struggling operation in January 1969.

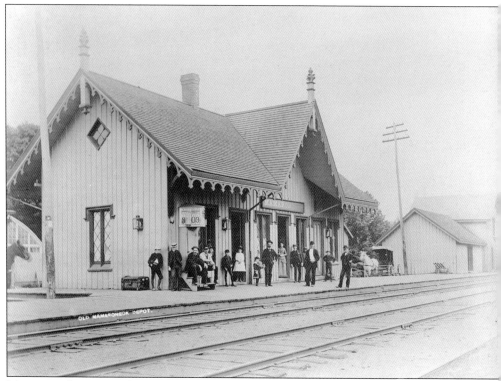

Mamaroneck's c. 1860 depot was at street level near Hoyt Avenue. A larger Romanesque-style station was built in 1888, with early-1900s track grading raised from street level. Today, some freight trackage at Marvel Industries is a remnant of street-level trackage. Victorian wooden stations, a common sight for New Haven line stations, are gone, but examples can still be found in Connecticut. A basic railroad at first, the line grew in importance as access improved in 1917 when the Hell Gate Bridge opened. (Courtesy of the Westchester County Historical Society.)

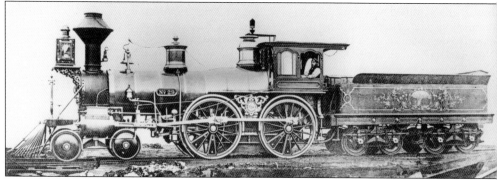

New Haven trains accessed New York City at Woodlawn Junction via the New York & Harlem Railroad. The engine shown, a 4-4-0 American type, was built in 1867 by Danforth & Cooke. A small lantern behind the smokestack signifies a New Haven train on the New York & Harlem Railroad for telegraphers. Initially, the Harlem Railroad was reluctant to grant access over its track but was court ordered to do so; regulators generally favored railroad furtherance. Both railroads squabbled over this entire leasing arrangement until their 1969 merger. (Courtesy of J.W. Swanberg.)

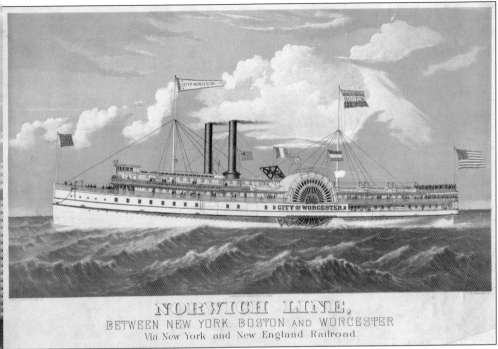

NORWICH LINE,
BETWEEN NEW YORK, BOSTON AND WORCESTER
Via New York and New England Railroad.

Coastal steamship lines joined railroads' portfolios in the 1800s, extending service on difficult-to-serve corridors—namely New York to Boston. Bays, rivers, and marshes hampered the completion of that corridor until 1892. Instead, railroads often crafted hybrid boat-train services where passengers transferred between boats and train. This New York & New England Railroad (NY&NE) steamship, shown on New Haven's Fall River line, used ships to railheads for a luxury 15-hour overnight trip. After fading slowly since 1889, boat/train service ended in a 1937 strike on bankrupt New Haven's Fall River line. (Courtesy of the Library of Congress.)

As railways matured, steamship or ship/rail travel to New England waned in favor of rail. One interesting early example was the New York & New England's *White Train*. NY&NE's prime six-hour New York–to–Boston train is shown here leaving Boston. Between 1891 and 1895, the NY&NE took a route via Hartford and then over the New Haven via Westchester into New York. Shown leaving Boston, it was a feature train with a six-hour timing but was discontinued two years after New Haven completed its shoreline route through Providence in 1889. (Courtesy of the Westchester County Historical Society.)

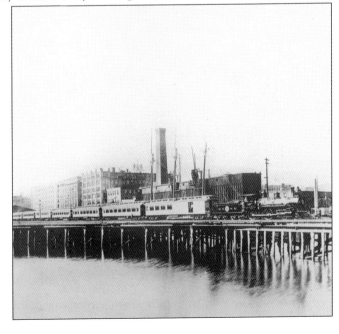

NEW YORK TO STAMFORD
WEEK-DAYS



Mls	Station
0.0	N.Y. G.C.T. Lv / 125th St. / Penna. Sta.
13.8	Mount Vernon
14.5	Columbus Ave.
15.2	Pelham
16.6	New Rochelle
18.7	Larchmont
20.5	Mamaroneck
22.2	Harrison
24.1	Rye
25.7	Port Chester
28.1	Greenwich, Conn.
29.6	Cos Cob
30.3	Riverside, Conn.
31.3	Sound Beach
33.1	Stamford Due

(Train columns: 292, 294, 188, 96, 190, 82, 252, 128, 118, 192, 50, 130, 272, 196, 258, 254, 88, 198, 200, 282, 132, 236, 260, 262, 166, 274, 134, 150, 202, 152, 72, 204, 90, 184, 206)

WEEK-DAYS

(continued — train columns: 284, 58, 208, 286, 154, 244, 156, 256, 238, 136, 210, 290, 138, 158, 212, 140, 214, 234, 142, 242, 216, 144, 160, 146, 218, 280, 162, 164, 220, 222, 66, 224, 296, 226, 228, 108, 32, 70)

WEEK-DAYS / SUNDAYS

(continued — train columns: 230, 232, 96, 190, 82, 252, 362, 100, 380, 50, 364, 382, 258, 88, 384, 366, 262, 90, 184, 206, 370, 372, 278, 374, 74, 64, 386, 76, 66, 224, 388, 296, 376, 32, 70, 230)

STAMFORD TO NEW CANAAN
WEEK-DAYS / SUNDAYS

Miles	Station
0 0	Stamford Lv
2 5	Glenbrook
3 6	Springdale, Conn.
3 9	Springdale Cemetery
4 9	Woodway
5 7	Talmadge Hill
7 9	New Canaan Due

(Train columns include: 500, 502, 528, 530, 504, 506, 508, 522, 510, 236, 512, 514, 516, 238, 518, 520, 524, 526, 532, 534, 536, 538, 540, 542, 512, 544, 546, 520, 548, 524, 526)

NEW ROCHELLE TO HARLEM RIVER
WEEK-DAYS / SUNDAYS

Mls	Station	303	307	311	329	317	319	313	321
		A.M.	A.M.	A.M.		P.M.	P.M.	P.M.	P.M.
0 0	New Rochelle Lv								
0 7	Woodside								
1 7	Pelham Manor								
3 3	City Island Station								
4 3	Baychester								
5 5	Westchester, N.Y.								
6 1	Morris Park								
6 7	Van Nest								
7 1	West Farms								
8 3	Westchester Ave.								
9 1	Hunt's Point Due								
9 6	Casanova								
10 5	Port Morris								
11 5	Harlem River, Willis Ave. and 133d St. Due								

Footnotes:

b On Saturdays and holidays leave 4 10 p.m.
c By connecting train.
f Stops on signal.

h Stops to take.
u No baggage carried on this train.

bb Stops 4 31 p.m. to take.
ss Stops Saturdays only.
LL—Trains indicated thus leave from the lower level tracks Grand Central Terminal.

‡ Except Saturdays.
♦ Baggage is handled on train No. 307 between New Rochelle and Hunt's Point only.
✚ Will not run July 5 or September 6.
(See Holiday Poster for special stops.)

6-13-26

This summer 1926 eastbound New Haven Railroad schedule shows three services, led by the New York–Stamford suburban mainline timetable. Next, the New Canaan Branch, though not in Westchester, had then and still has some customers from remote parts of northeastern Westchester, such as Pound Ridge. The lower panel shows the 1931 discontinued New Rochelle–Bronx service, which included stops at Pelham Manor and City Island Station to Hunts Points, where a NYW&B connection was needed to reach the Harlem River station to access New York subways. (Courtesy of Otto M. Vondrak.)

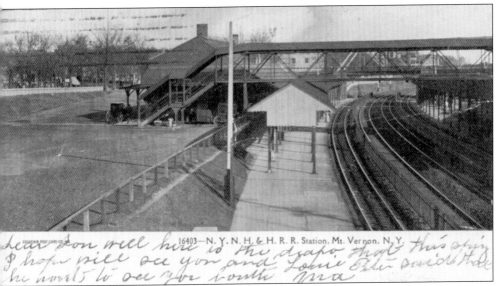

16403—N. Y. N. H. & H. R. R. Station. Mt. Vernon. N. Y.

Today's New York–Westchester–Boston route was fully in place, made possible by Morgan leasing the Massachusetts-based Old Colony Railroad, adding the needed Boston link from Providence, Rhode Island. By now, the New Haven was a robust system under Morgan, evidenced by this new four-track mainline station in Mount Vernon around 1903, a few years before an overhead catenary wire electrification was installed in 1907 in preparation for Grand Central access. A freight branch to Harlem River from nearby New Rochelle was built, and thoughts about building into Manhattan via bridge were pondered. (Courtesy of the Westchester County Historical Society.)

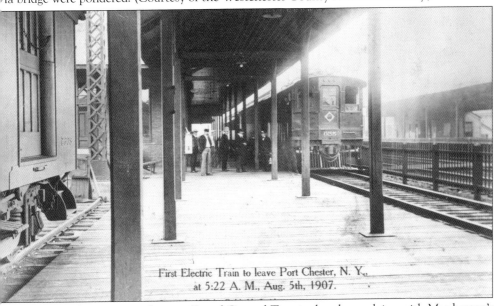

First Electric Train to leave Port Chester, N. Y., at 5:22 A. M., Aug. 5th, 1907.

In preparation for accessing the new Grand Central Terminal and complying with Manhattan's steam ban, the first electric train is seen here leaving Port Chester in 1907. The locomotive is a Westinghouse EP-1, nicknamed "Pony," the first of a series of EP units, denoting electric passenger motor. Designed in 1905, thirty-five were built. New Haven's electric locomotive construction was more complicated than New York Central motors, since New Haven preferred AC power, while the Central used simpler DC power. (Courtesy of J.W. Swanberg.)

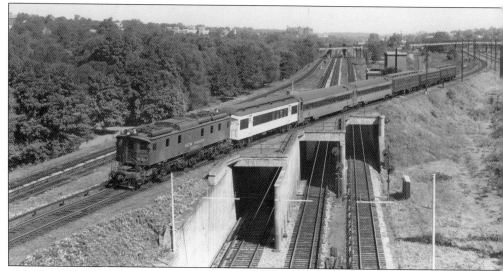

This is a view of Woodlawn Junction, the west end of the New Haven line, and end-point of wire power at right, where New York Central's DC third-rail power is used into GCT. A train from Springfield, Massachusetts, is seen approaching the Harlem line tracks. Mount Vernon, just north, is at right. This 1950s photograph shows a soon-to-be-retired World War I era Baldwin-Westinghouse EP-2, the next passenger motor purchase after the earlier EP-1. Twenty-six were built. They had 2,460 horsepower and ran quite economically. (Courtesy of J.W. Swanberg.)

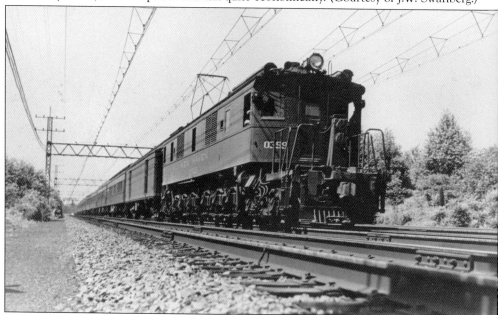

Shown in 1944 is one of 10 of the newer electrics, a General Electric Erie, Pennsylvania–built EP-3, with a Boston express doing 80 mph over the "Mamaroneck Speedway." Through the first third of the 20th century, New Haven continued to acquire more rail traffic, needing heavier motive power. The very successful early GE electric locomotive of 1931 vintage pictured here was newer than appearances; inside that Edwardian body, newer electric traction technology was used for subsequent electric locomotives. New Haven was unique in its reliance on passenger revenues, which amounted to over one third. (Courtesy of J.W. Swanberg.)

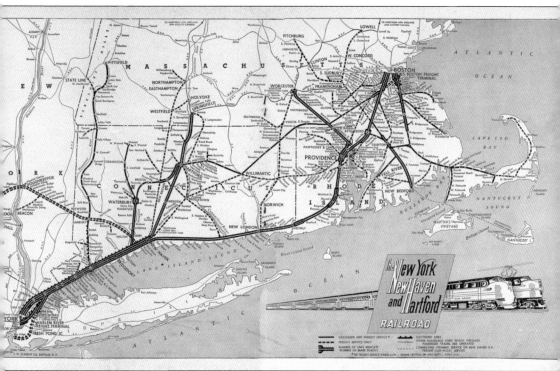

Seen here is a map of the New Haven's 1952 empire nearing its twilight of prosperity. Most of southern New England is seen under the New Haven flag. Most of the carrier's Morgan era subsidiaries of trolley lines, steamship companies, bus companies, and Westchester's New York, Westchester & Boston are gone, as are some early lines shed since the 1930s. At far left is New Haven's part of the 1904 acquired Central New England Railroad. It was fully merged by 1927. The Maybrook Line allowed the carrier's desired connections to Western and Southern railroads. It passed through southeast Putnam County, reaching about a mile above Westchester's North Salem, where the little-used tracks are still in place. Also shown is a short but busy four-track New Haven portion in Westchester, with lines splitting at New Rochelle to Grand Central, or south to the Hell Gate Bridge and city freight terminals. Over a third of New Haven's revenue was dependent upon passenger, mail, and express, the most among class one railroads in the United States, since railroads inherently depend—then and now—on freight for most income. Among those thin lines, the New York Central Railroad's westward Hudson, Harlem, and Putnam Lines are shown. (Courtesy of the New Haven Railroad Historical & Technical Association.)

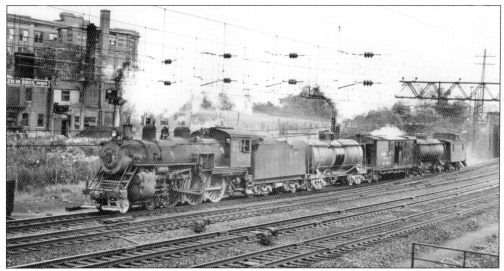

Westchester's New Haven had one drawback for train watchers: the lack of steam. One had to travel east to New Haven to see steam in quantity, with some exceptions. Maintenance trains, such as the catenary wire-train, or this track-oiling train, had a small niche where electric use was not practical. This gritty 10-wheeler at New Rochelle, a Baldwin product of 1906 vintage, was once a proud passenger speedster, but it is seen here in work service. It was photographed by the tower operator at SS-22, meaning signal-station at milepost 22. (Photograph by H.L. Goldsmith, courtesy of J.W. Swanberg.)

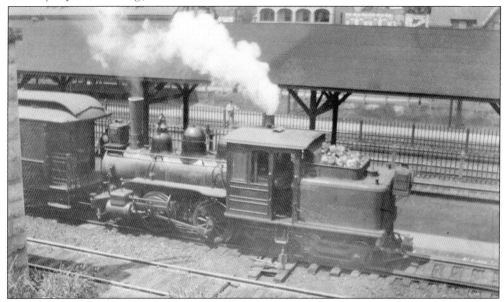

Another steam exception were these diminutive elevated railway–type Forney 0-4-4T engines and coaches shuttling commuters between New Rochelle, intermediate points like Pelham Manor and Bronx, to New Haven's tiny Bronx Terminal until New Haven's electrification efforts in the 1900s. This service was incentivized with 40 percent cheaper fares, crafted by passenger transferring to the city transit's Third Avenue El in the Bronx at 129th Street, later 135th Street. New Haven aimed to divert commuters from Grand Central to its own small Bronx terminal to capture full-fare revenues. (Courtesy of J.W. Swanberg.)

Cabooses on mail trains were rare, with an old rider coach more common. However, the New Haven preferred specially outfitted cabooses for mail trains that kept passenger-like paces. Shown at New Rochelle, this westbound train from Boston to New York passes in the late 1930s. Nationwide, mail and express traffic contributed much to passenger revenue, often keeping marginally ridden trains running. (Photograph by J.W. Swanberg.)

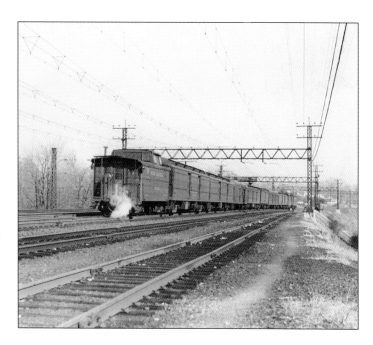

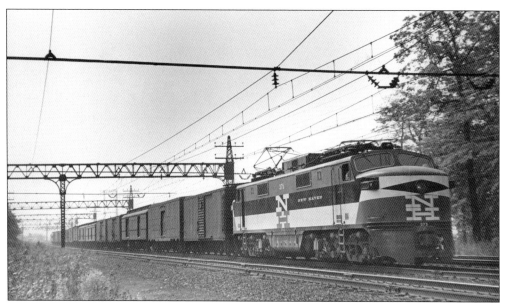

South of New Rochelle, on the Harlem River branch, an eastbound mail train from Pennsylvania Station hauling mail cars from as far south as Miami or New Orleans in 1957 uses the newest power, one of 10 electric GE 4,000 horsepower EP-5s, nicknamed "Jets," so the oldest motors could retire. The New Haven soldiered on with adversities such as depressions, weather issues, and malfeasance, but there also were many decades of prosperity and fine management. (Photograph by F.G. Zahn; courtesy of J.W. Swanberg.)

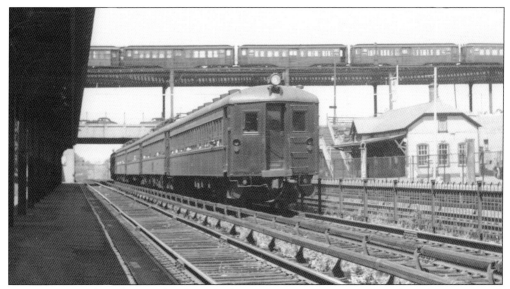

New Haven used Harlem tracks through the Bronx, with no stops allowed until Metro-North days. This commuter train of 1926 vintage MU cars is seen using the express track at Williams Bridge around 1950. Behind is the Interboro Rapid Transit (IRT) Third Avenue elevated over US Route 1. Roughly 100 daily commuter trains served stations between Mount Vernon and Port Chester, with most trains using Stamford, Connecticut, as the terminus. Also, about 80 daily trains traveled northeast to Connecticut, Boston, and other New England points. (Photograph by Robert Boeddener, courtesy of J.W. Swanberg.)

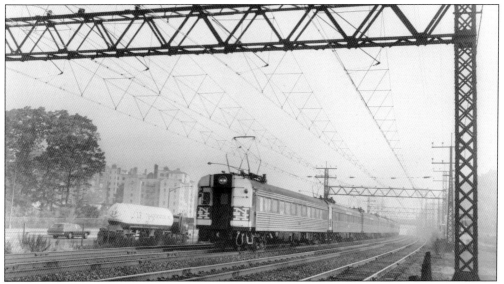

This c. 1954 MU train equipment type was nicknamed "Washboards" due to the corrugation; these Worcester, Massachusetts–built Pullman Standard cars, constructed in the former Osgood-Bradley car plant, were a hundred-car purchase, allowing the New Haven to triage retirements of the worst and oldest commuter equipment, with some dating to before 1910. In the background behind an eastbound New York express at Larchmont in 1974 is a cluster of station-accessible housing. At this time, much of the old New Haven electric fleet was being replaced by new GE built M-2 cars. (Photograph by Bob Lorenz; courtesy of J.W. Swanberg.)

This is not a regular two- and three-seated 96-commuter MU passenger coach; rather, it is one of four subscription club cars added to a few key commuter trains that called at Rye and Larchmont, plus Connecticut's New Canaan and Greenwich, which abut Westchester. Subscribers would pay the monthly commuter fare plus a hefty fee for access to clubby luxury: plush chairs and bridge tables with waiter beverage service. Four such club cars and eight combination cars, which handled baggage as well as local mail until 1968, were in this hundred-car purchase. (Courtesy of J.W. Swanberg.)

	♦26	♦360	374	♦240	80	82	♦332	♦298	♦204	♦300	♦304	♦302	♦376	♦242	♦358	♦206	♦208	♦294	♦210	28	472
Conditions	Daily	Ex Sun & Hol A	Ex Hol A	Ex Sat Hol A	Ex Sun	Sun only	Ex Sat Sun & Hol A	Ex Sat Sun & Hol A	Ex Sat Sun & Hol A	Sat Sun & Hol A	Ex Sat Sun & Hol A	Sat Hol A	Ex Sat & Sun	Ex Sat Hol A	Ex Sat Sun & Hol A	Ex Sat Sun & Hol A	Ex Sat Hol A	Ex Sat Sun & Hol A	Ex Sat Hol A	Daily	Ex Sun
New York Grand Central. Lv.	PM 5 00	PM 5 00	PM 5 05	PM 5 08	5 10	5 10	PM 5 12	PM 5 14	PM 5 16	PM 5 23	PM 5 29		PM 5 31	PM 5 32	PM 5 34	PM 5 35	PM 5 48	PM 5 51	PM 5 54	PM 6 00	PM
125th St. ⊠	5 10	5 15	5 18	5 18	5 20	5 20	5 22	5 24	5 26	5 33			5 41	5 42	5 44	5 45		6 01	6 04	6 10
Penna. Station				LL		LL			LL		LL				LL		LL	LL	LL		
Mount Vernon.....Due										5 42	5 49						6 01	6 15	6 20		
Columbus Ave.										5 46	5 51						6 03	6 17	6 23		
Pelham										5 50	5 54						6 06	6 20	6 27		
New Rochelle			5 38					5 53			5 58				6 03	6 10	6 24		6 31		
Larchmont			5 43					5 56			6 07				6 08		6 24		6e35		
Mamaroneck			5 47								6 07				6 12		6 28		6e39		
Harrison			5 55								6 10				6 16		6 32		6e42		
Rye			5 55							6 04	6 13	6 09			6 19		6 35		6 45		
Port Chester, New York			ee	5 58				5 54			6 17	6 14		bb	6 22		6 39		6e49		
Greenwich, Conn.			ee					5 59			6 22	6 20		bb			6 44		6e54		
Cos Cob								6 02			6 25	6 24					6 47		6e57		
Riverside, Conn.								6 04			6 27	6 27					6 49		6e59		
Old Greenwich			5 51					6 07			6 30	6 31					6 52		7e02		
Stamford			5 55		5 57	6 00	6 11				6 33	6 35		bb		6 24	6 55		7e05	nn	
Glenbrook																6 29					
Noroton Heights			6 01											bb		6 33					
Darien		5 52	ee			6 04										6 36					
Rowayton			6 06											bb		6 38					
Norwalk and South Norwalk		5 57	6 11			6 09								6 33		6 43					
East Norwalk			6 14											6 38							
Westport and Saugatuck		6 03	6 20			6 15								6 42							
Green's Farms		6 08	6 25											6 47							
Southport		6 12	6 29											6 51							
Fairfield		6 15	6 35											6 56							
Bridgeport		6 24	6 43		6 19	6 28								7 05						7 11	7 17
Stratford		6 30	6 54											7 10							7 22
Milford		6 37	7 04			6 38								7 17							
New Haven.....Due	6 18	6 47	7 14		6 37	6 48								7 27						7 29	
	PM	PM	PM	PM	PM	PM	PM	PM	PM	PM	PM	PM	PM	PM	PM	PM	PM	PM	PM	PM	PM

LL—Trains so indicated leave from the lower level Grand Central Terminal.
⊠ Outbound trains stop at 125th Street only to take passengers.
♦ No checked baggage service on this train.
Holidays A—May 30, July 4 and Sept. 1.
Note I—Will run Fridays, July 11 to August 29, incl. Also Thursday, July 3.
e Stops only on Saturdays.
y No checked baggage service on Saturdays and Sundays.
z No checked baggage service on Saturdays.
as Stops on Sundays and Hol A only at Stamford 4.56 PM, Norwalk & So. Norwalk 5.04 PM

bb Stops only on Holidays A at Port Chester 6.09 PM; Greenwich 6.12 PM; Stamford 6.19 PM, Noroton Heights 6.23 PM; Rowayton 6.29 PM.
ee Stops Saturdays only at Port Chester at 5.42 PM and Greenwich 5.45 PM; Darien 6.04 PM
nn Stops at Stamford at 6.46 PM weekdays to take passengers; Sundays makes a regular stop.

Page 14 in New Haven's April 1952 system timetable shows evening commuter traffic. In some ways, it does not look much different than today's schedules, except for premier trains like the *Merchants Limited* to Boston and the *Connecticut Yankee* to Hartford. Note the 5:23 p.m. train from New York; Westchester's poshest train had two subscription cars. Stops were only at Larchmont and Rye, and the only suburban trains to Grand Central's preferred upper level. The morning counterpart arrived in New York at a comfortable 9:00 a.m, showing a different executive lifestyle. (Author's collection.)

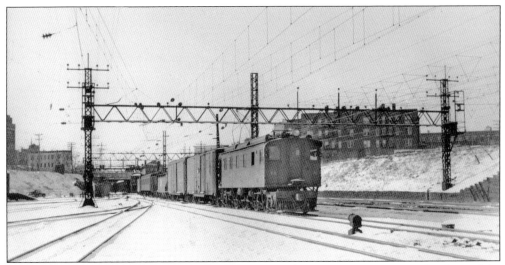

Mount Vernon was among the few industrial cities in the county, warranting a freight yard for local shippers and receivers. Another local freight yard was in Port Chester. This 1930s photograph shows a Baldwin Westinghouse EF-1, one of 39 such motors and the New Haven's earliest freight power in 1912 when the line mostly converted from freight steam haulage on the west end, or New York area. Diesels began taking over local freight duties by the 1950s, although through mainline freight was mostly electric hauled through 1969. (Courtesy of J.W. Swanberg.)

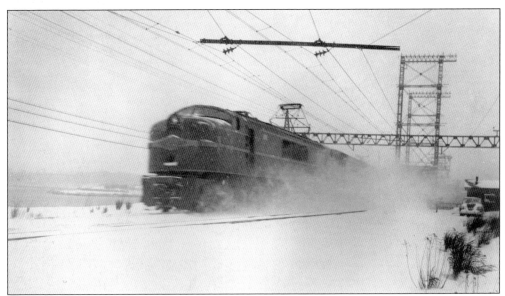

This blizzard view is courtesy of tower operator H.L. Goldsmith, who trudged through the snow to Pelham Bay's Hutchinson River drawbridge near Long Island Sound. This streamlined 1941-built EF-3 was among 10 such electrics built, with the order split between GE and Baldwin-Westinghouse. There were also similar passenger units built, EP-4s. These efficient units took an early retirement by 1959 at the end of the 1950s McGinnis era of bankruptcy, brought about by greedy strategies such as cutting service and maintenance expenditures and shunning electric operations. (Photograph by H.L. Goldsmith; courtesy of J.W. Swanberg.)

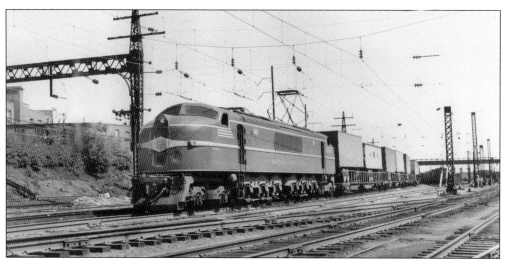

Jack Swanberg captured this late 1950s Boston–to–New York hotshot trailer-on-flatcar (TOFC) train departing New Haven for the Bronx's Oak Point. It will sprint about 65 mph through Westchester. Truck trailers got hauled to area consignees. This train had some cars with a short-lived Clejan holding system. The train's schedule and service design addressed a looming highway threat to railroads; government funding of highways unwittingly subsidized competition. All county lines eventually lost virtually all of their freight traffic to trucking. (Photograph by J.W. Swanberg.)

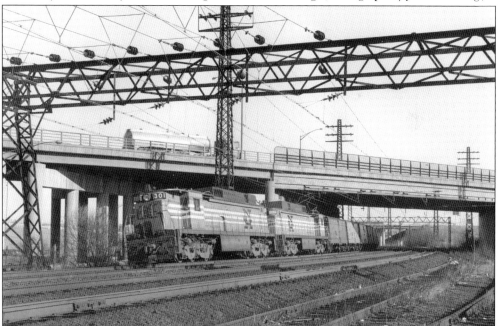

A westbound perishable freight passes in 1964 under Interstate 95 at Rye using 1959 acquired ex–Virginian Railway GE-built EF-4s. Ten bargain-priced rather new electric locomotives were purchased by New Haven trustees in an effort to reverse the locomotive shortage precipitated by the McGinnis years. These units covered the electric 65-mile portion well. Court-appointed trustees, some of whom were railroad operating people proficient in managing the railroad's company affairs, made fine decisions and did a commendable job in those circumstances. (Photograph by Ronald Rypkema, courtesy of J.W. Swanberg.)

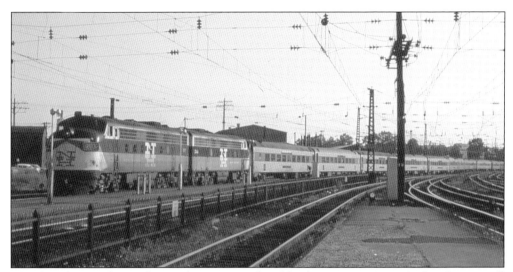

Like the trustees, the employees also ran a tired and bankrupt New Haven Railroad quite well and were able to maintain some standards, such as this 1968 westbound New York to Boston *Merchants Limited*, photographed by locomotive engineer Peter McLachlan during a break, dutifully taking his camera to work. At this time, clean locomotives and a matching streamliner consist were a rare sight. Most trains, both commuter and long distance, were made up of a hodgepodge of equipment, with some dating to the 1920s. (Photograph by Peter McLachlan.)

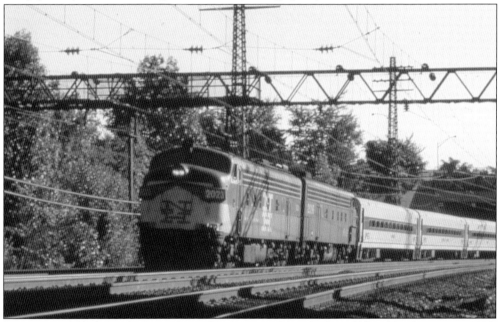

New Haven folded into the Penn Central in January 1969, which itself faced bankruptcy in 1970. The freight side of railroads here was restructured into Conrail. The Connecticut Department of Transportation (CDOT) and New York's Metropolitan Transportation Authority created Metro-North Railroad by 1983, encompassing Westchester's three lines. The New Haven line with CDOT input kept some New Haven Railroad identity, as shown on this General Motors late-1950s FL-9. The FL-9 was dual-mode electric and diesel. (Courtesy of the New Haven Railroad Historical & Technical Association.)

Five

THE NEW YORK, WESTCHESTER & BOSTON RAILROAD

In 1912, moving toward the railway boom's autumn, a new concept arose: rapid transit. The New York, Westchester & Boston (NYW&B) was conceived around the concept of smokeless, electric, fast, frequent, and cheap propulsion with the latest technology, yielding endless commuters.

In 1872, the NYW&B was chartered as a conventional railroad along a Bronx-Westchester routing toward New England but was quashed into dormancy by the 1873 financial panic.

In the prosperous 1890s, with new investors, the New York, Westchester & Portchester Railway was planned roughly paralleling the New Haven and NYW&B's service areas, but more significantly, it was designed from scratch as a "rapid transit railway." Much of the plan and conception was by early electric railway developer William C. Gotshall, who refined trolley-car technology into modern electric-operating hardware that mainline railroads could use, such as heavy catenary-wire systems, transformers, and multiple-unit operation. This, combined with just developed rail passenger innovations, frequent schedules, and a growing county market, seemed ideal.

Eying this concept taking shape, a competition-averse J.P. Morgan saw a threat taking shape in his sphere and quietly confounded Gotshall's efforts, entering with his own similar proposal instead. Armed with more money and Tammany Hall connections, Morgan seized the idea, reformulating it toward a New Haven vassal. Morgan, with deputy Charles S. Mellon, managed to pay just a few million dollars for Gotshall's envisioned railroad.

Some felt that Morgan was just too enamored by the project's modernity, overlooking that his transit project was questionable; having NYW&B operate near the New Haven would be redundant. Nevertheless, construction began in 1909.

Deleterious to this transit railroad was the absence of desirable subway compatible equipment accessing throughout Manhattan. Morgan's corporate behemoth preferred New Haven's own 11,000-volt AC Westinghouse overhead electric system. It was modern, but not Edison's 600-volt DC subway-compatible power system, allowing access into New York City subways. Many feel this was the grave error in attracting riders, as trains from White Plains, New Rochelle, and eventually Port Chester terminated in the Bronx, requiring a transfer to subways and elevated lines.

The railway largely met operating costs, but not capital and debt costs. Declining patronage, the Great Depression, and over $1 million in annual debt service for roughly $50 million, which often eclipsed passenger revenues, all led to the Westchester's demise in 1937.

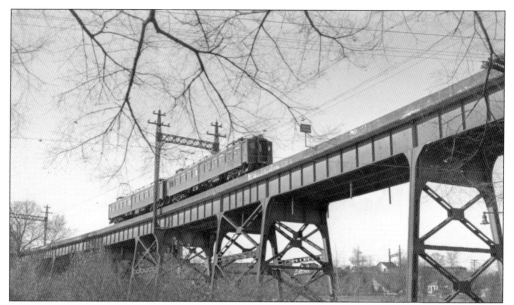

Electricity came of age with boundless speed and efficiencies that steam could not attain. The Westchester also employed new innovations to save travel time, such as introducing center doors for faster unloading with raised passenger platforms, new to commuter railroading. This 1937 photograph, taken two months before the Westchester shut down, shows a Port Chester train crossing the Hutchinson River Valley in Pelham. Rail historian Herbert Harwood wrote that this railway was both a perfect railroad and J.P. Morgan's magnificent mistake. (Photograph by Alfred Seibel, courtesy of the City of New Rochelle Public Library.)

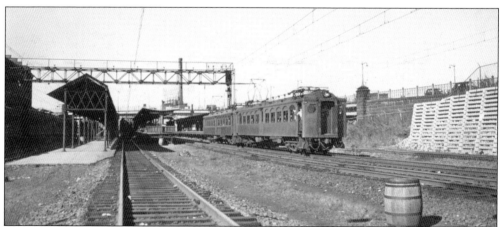

The NYW&B southern terminal was a small four-track facility on New Haven Railroad property. Passengers needed to transfer here to access Manhattan subways, which was a drawback for prospective commuters. Instead, fares over a third lower via this mode gave access to Manhattan's many subway destinations versus strictly Grand Central Terminal. Later, in 1919, a quicker IRT subway connection at 180th Street helped boost traffic. Traffic did grow, doing so even faster than the competing commuter lines in the county. (Courtesy of Robert A. Bang.)

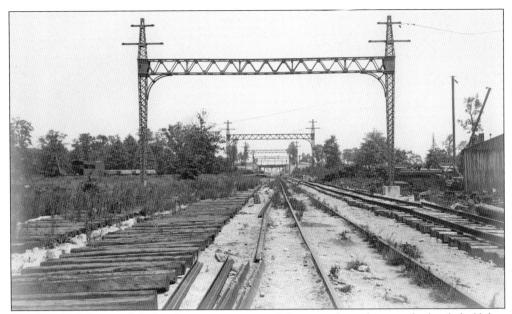

One hundred thousand daily riders were anticipated, but actual numbers reached only half that figure by 1929. Shown is a portion of four-track under construction from the Bronx Harlem River Terminal to Westchester at Mount Vernon. The New Haven catenary poles are just installed, with early track construction about 1910. Pre–New Haven's NYW&B issued common stock, which was bought back or converted to New Haven stock. Much of these buyback proceeds went to politicians and influenceable people, costing millions; just another footnote in the New Haven's financial history. (Courtesy of the Westchester Historical Society.)

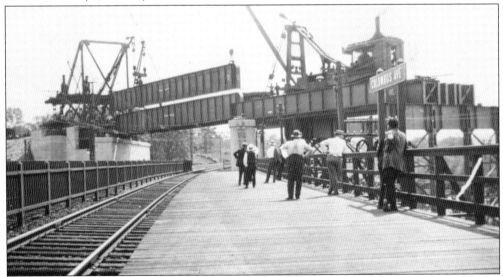

The Westchester's heady progress is seen here in 1911 as an overpass piece gets lowered over the New Haven tracks at Mt. Vernon's Columbus Avenue station, enabling transfers between the two rail lines. NYW&B's 11,000 AC overhead wire system, compatible with the New Haven, allowed the railroad to use the same power source at Cos Cob, Connecticut. At times, the New Haven Railroad would lend support in the form of land, freight cars, and sometimes, a small electric locomotive. (Photograph by Harry F. Brown, courtesy of J.W. Swanberg.)

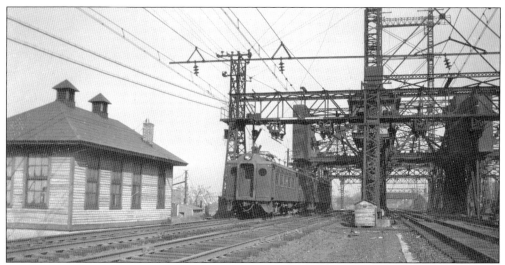

Pictured here is the Bronx River drawbridge. This six-track right-of-way includes the New Haven's Harlem River branch at right. Within a mile north of this point at Greens Farms Junction is where the NYW&B tracks diverge left on their own path after leaving New Haven's right-of-way. Just further is Bronx Park–180th Street station and NYW&B's maintenance shop, where improved subway connections arrived in 1919. Today, the classic NYW&B station remains, now part of MTA subways, and the still-operating MTA segment to Dyre Avenue starts here. (Photograph by George Votava, courtesy of Robert A. Bang.)

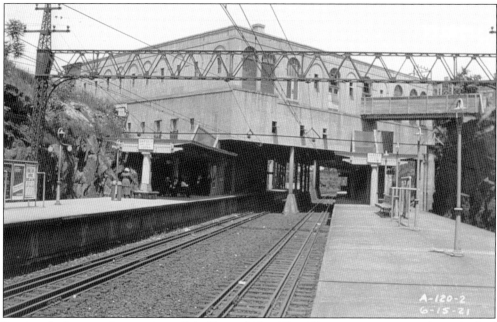

Station platforms and a rear view of Mt. Vernon's East Third Street station are seen here. Arched windows and front columns were common features of NWW&B stations and were inspired by classic Italian and Spanish architecture. Ostentatious stations like this contrasted with NYW&B's austere Bronx Terminal—another mystery of this railroad. Initially, the Westchester route extended into Westchester on two lines: White Plains and New Rochelle, which later was extended to Port Chester by 1929. (Courtesy of Herbert H. Harwood Jr.)

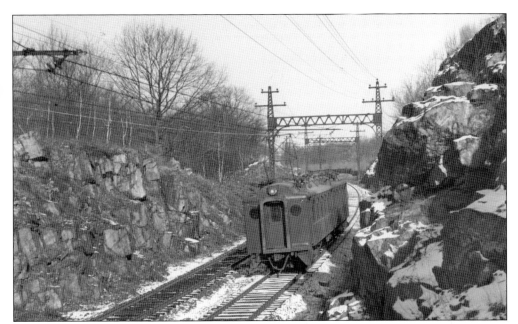

The Westchester's White Plains branch skirted most urban population centers, traversing what some may describe as southern Westchester's wilderness, passing through rural portions of Scarsdale and New Rochelle, as seen in this 1937 photograph at Wykagyl. While numerous NYW&B areas did develop, they never grew to the expectations of developers. Single-family homes sprung up instead of large apartment buildings. Such urban growth mostly remained in the Bronx and a few enclaves on the second line to Port Chester. (Courtesy of Robert A. Bang.)

This schematic map illustrates the NY&WB routes from the Bronx to White Plains and Port Chester. Initially, service was to White Plains and New Rochelle, with a 1920s expansion to Port Chester. The Port Chester expansion helped push Westchester's ridership to 14 million, yielding a $400,000 net profit in 1928. Ultimately, the Port Chester line carried the most passengers but diluted revenue from its parent New Haven Railroad. (Map by Otto M. Vondrak.)

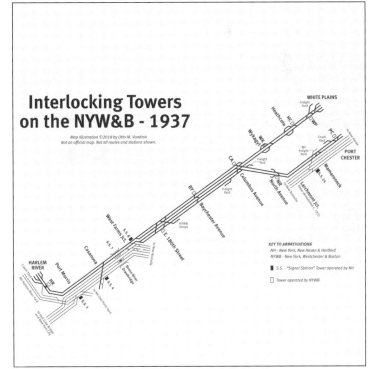

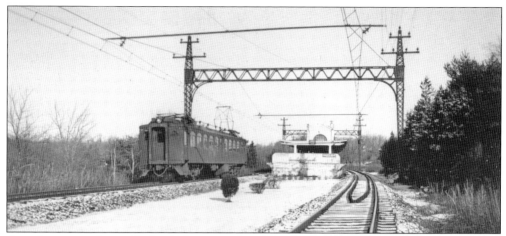

A single-car train leaves Quaker Ridge in northern New Rochelle, heading to Scarsdale. Ridership in the first few years after the 1912 startup was expected to be low, at about 800 daily rides. A land development company was formed. Much trackage came through wooded areas that continued to surround the station. Much of the property was eventually built upon after the 1937 abandonment. In this market, passenger counts during midday were light, sometimes in the single digits. (Photograph by John Tolley; courtesy of Robert A. Bang.)

Quaker Ridge Station is shown here after the railway's closure. It was used as an artist's residence around the 1950s. Several station buildings remained intact for other uses. Architects Reid & Fellheimer designed most NYW&B buildings. Ironically, when service began in 1912, almost universally, railroads with commuter operations were discovering that commuter services were not profitable. Amidst a new NYW&B, railroads with commuter operations going forward would limit expenses and send older depreciated locomotives and cars to commuter operations. (Courtesy of the City of New Rochelle Public Library.)

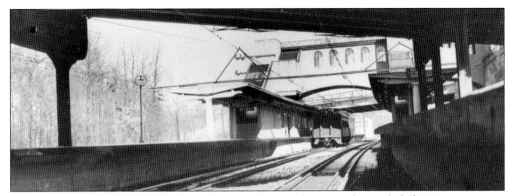

Beneath eastern Scarsdale's Heathcote depot is a four-track station that included two outer passing tracks in anticipation of many passengers, then adding enhanced express service, which never happened. While several stations had this feature, it was another example of the overbuilding and redundancy that would hurt the railway's solvency. Although the New Haven Railroad bought back all common stock by 1909 to allow construction, there was still about $50 million outstanding in NYW&B bonds. (Photograph by George Votava; courtesy of Robert A. Bang.)

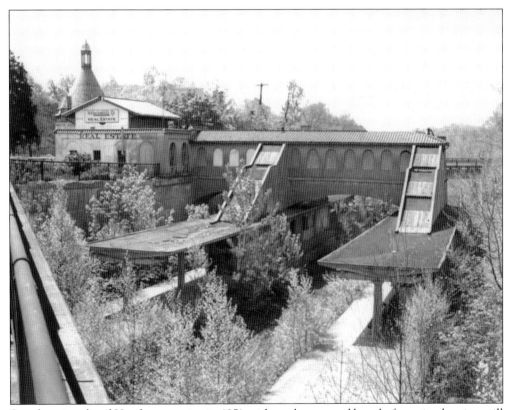

Seen here is a closed Heathcote station in 1951, with tracks removed but platforms in place in a still sparse area. Urban development never came to most of NYW&B's White Plains branch territory. Eventually, a two-lane highway would be paved over the old right-of-way for about a mile. Roads built over former railroads is not unusual. Today, the station area is being expanded to a multi-residential building 80 years after the trains left. (Photograph by Herbert H. Harwood Jr.)

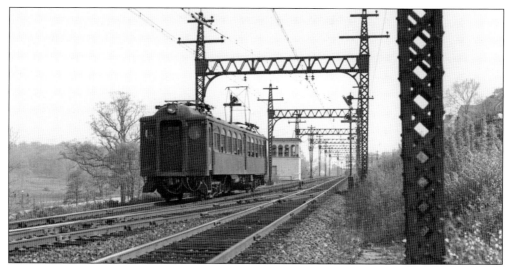

Nearing White Plains, with New York Hospital property visible at left, this location has largely been developed, although level grading can still be found. Aside from some buildings where the tracks are today and Bloomingdale's department store, much of the wooded area at left is intact today. The NYW&B president was Leverett Miller, who had a Morgan connection and varied experience. Miller innovated scheduling subsidiary bus and trolley lines to connect with NYW&B and New Haven trains, thus introducing feeder bus service. Born in 1863, he was once a Western railroader. Later, he also helped county transit development. (Courtesy of J.W. Swanberg.)

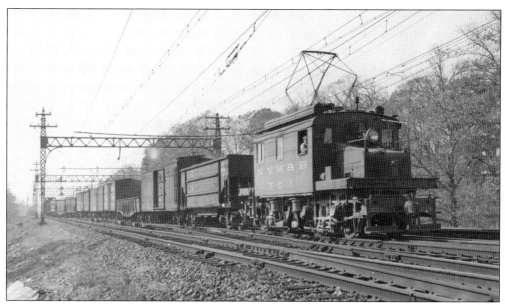

The Westchester's solitary electric engine for its minimal freight service is shown here around 1936, at a time when freight traffic continued its decline, often to single-digit freight cars per run. Small yards for local shippers were known at White Plains, Heathcote, and Mount Vernon Junction. Eventually, after railway closure, among the paltry assets for bondholders, this motor was bought by the New Haven, joining its own 22 similar 1911-era units. This B-B eight-wheel Baldwin-Westinghouse unit had Baldwin build the motor's body, with Westinghouse installing the motors and wiring. (Courtesy of J.W. Swanberg.)

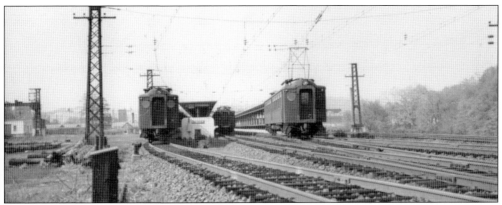

This image looks north into the White Plains Terminal. The two-platform, four-track terminal, with some additional storage trackage just south, also kept a small freight yard just west of roughly three tracks. The White Plains branch was built first, but unfortunately, it never carried the number of anticipated passengers. Later, a line to Port Chester yielded far more; however, the railway would soon be on borrowed time. Today's Bloomingdale Road is at right. (Photograph by George Votava; courtesy of Robert A. Bang.)

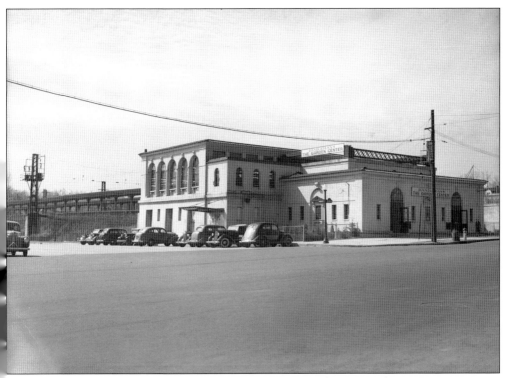

The White Plains terminal was built in Italian Renaissance style on Westchester Avenue. Prior to demolition, it spent a period as Handleman's Garden Center, but was demolished in 1951 for the new Altman's Department Store (and later the Westchestcher Mall). This was once considered the back area of White Plains. The black girder atop the building was reinforcement for an added level for the never-built Westchester Northern Railroad, intended to be yet another Morgan project to move freight through northeastern Westchester towards Danbury, Connecticut, then a key freight access. (Courtesy of the Westchester County Historical Society.)

982	994	858	666	994	996	860	668	986	998	862	670	864	672	866	674	868	676	870	678	872	680	874	682	876	684	878	686	688	880	690	692	TO HARLEM RIVER (133d St.) fro...

TO HARLEM RIVER (133d St.) fro...
City Hall via 3rd Ave...84 mi
9th St. " ...16 mi
23rd St. " ...16 mi
42nd St. " ...14 mi
TO BRONX PARK (180th St.) from
Brooklyn Bdg.. via Lex. Ave...55 mi
14th St. " ...31 mi
G. C. Terminal ... " ...27 mi

Stations (with schedule times, PM):

Lv. Harlem River......
Port Morris
Casanova
Hunt's Point.
Westchester Avenue
Bronx Park (180th St.) — Bronx
Morris Park
Pelham Parkway.
Gun Hill Road.
Baychester Avenue.
Dyre Ave., 233rd St.
Kingsbridge Road.
East 6th Street — Mt. Vernon
East 3d Street..
Columbus Avenue...

North Pelham, 8th Avenue....
Pelhamwood
Webster Avenue. — New Rochelle
North Avenue...
Pine Brook
Chatsworth Avenue. — Larchmont
Larchmont Gardens..
Mamaroneck.
West Street... — Harrison
Harrison Ave...
Rye.....
Due Port Chester...

Mt. Vernon, East Lincoln Ave.*
Chester Heights...
Wykagyl
Quaker Ridge..
Heathcote
Ridgeway...
Gedney Way.... — White Plains
Mamaroneck Ave...
Due Westchester Ave...

...ension at Hunt's Point Station. * Adjacent to Willsons'Woods Swimming Pool of Westchester County Park Commission.

This schedule from the 1930s illustrates an ideal 20-minute train frequency unmatched by the other commuter lines. Like the subways, people could travel between the county and city at almost all hours without needing to carry a timetable, as headways were 20 minutes apart. Through service with subway compatibility to this would have been ideal. The 20-minute frequency, or headway, is still considered ideal on busy commuter railroads. (Courtesy of J.W. Swanberg.)

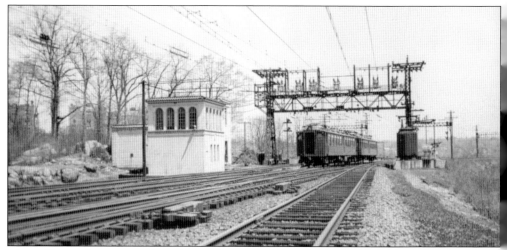

Mount Vernon Junction is where the two lines split. This was the railway's showcase interlocking. The term "interlocking" means a control point where traffic is directed; it also means "interlocked protection" from erroneous routing conflicts, with signal and mechanical protection. Given the traffic levels, this interlocking was a bit overbuilt in 1910, as evidenced by the costly double-slip switches, giving an overgenerous amount of costly flexibility. During the 1930s, many railroads would downsize such facilities to reduce high-maintenance expenditures. (Photograph by John Tolley, courtesy of Robert A. Bang.)

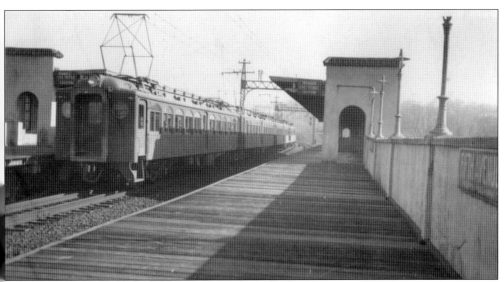

North Pelham's Fifth Avenue Station was one of two stops in Pelham enroute to New Rochelle, a terminus until a 1920s expansion toward Port Chester began. The Westchester was no longer in Morgan's empire after his 1912 demise, when a spell of chaos ushered in a more conservative management team. Frugality took hold in building the Port Chester portion, with cheaper construction and a slower pace. The methodical construction reached Mamaroneck in 1926, and finally Port Chester in 1929. (Courtesy of Robert A. Bang.)

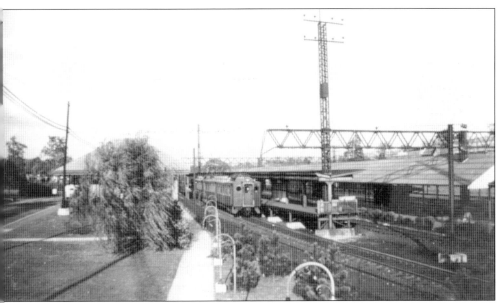

Larchmont opened in March 1921, encouraging fashionable apartment development. This view shows two Westchester tracks, with New Haven's mainline at right. New Haven used the NYW&B to divert short-haul Grand Central–bound passengers toward the Westchester's cheaper fares, keeping more revenues in-house. This line brought some success, as ridership surpassed 10 million by the late 1920s as the more urban stations went into service: Mamaroneck in 1926, Harrison in 1927, and Rye in 1928. An additional MU coach order was made to meet demand. (Courtesy of Herbert H. Harwood Jr.)

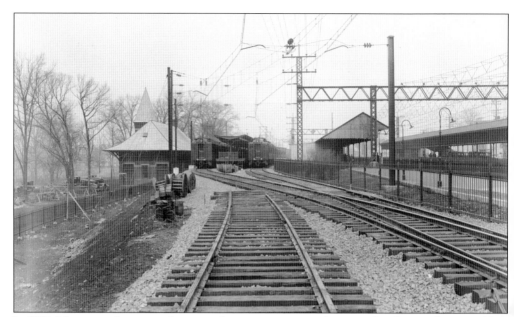

In 1926, Mamaroneck, in partial use, was sharing costs, using adjacent right of way and existing New Haven stations. Even the platforms were basic. The depot buildings at Larchmont, Mamaroneck, and Harrison were moved several yards west to allow the added tracks and platform. The Port Chester mainline took on decent traffic, with enough of a customer following to enable profits in operation, but unfortunately, it was offset by the unprofitable White Plains branch. Today, NYW&B catenary poles on the New Haven are still in use. (Courtesy of Herbert H. Harwood Jr.)

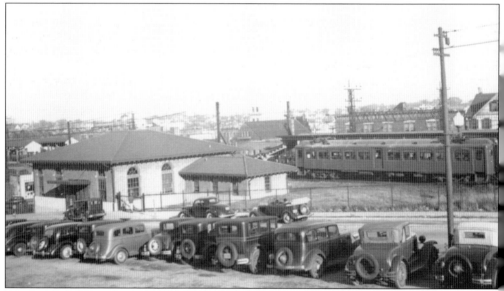

Almost 15 million rode in 1929, but the Depression meant losing a third of those passengers. The mill stone of $50 million in debt and the loss of optimism ended justifying servicing NYW&B debts. Parent New Haven's bankruptcy protection in 1935 sealed the Westchester's fate, as the railroad began unloading most of the late-Morgan-era acquisitions. Bondholders got small settlements in the 1940s from property, equipment, and copper wire sales. New York City Transit took over a segment from 180th Street to Dyre Avenue in late 1945. (Courtesy of Herbert H. Harwood Jr.)

Six

THE PUTNAM LINE

"The Old Put," or "the Put" were its nicknames. New England investors backed the new Boston, Hartford & Erie (BH&E), seeking a connection with the Erie Railroad across the Hudson River. Investors saw opportunity in cooperative western connections from Boston, even promoting joint services westward in competition with Vanderbilt's New York Central. The BH&E would have headed through Putnam and upper Westchester Counties, but like many startup railroads, it went bankrupt by 1870.

Next, New York & Boston Railroad investors, plus European backers, hoped to patch a corridor to Montreal, Canada, building south toward Manhattan. The New York, Boston & Montreal Railway suffered the same fate as BH&E in the Panic of 1873.

Bondholders holding claims of foreclosure instead encouraged the development of the railroad. The reorganized New York, Westchester & Putnam Railway raised the Put flag in 1879, building as the New York City & Northern (NYC&N). Modest Brewster, New York, not Montreal, became the goal, but with Boston-bound connections via Brewster.

Traffic was a respectable mix of iron ore from two mines, milk, local and distant freight, mail, express, and passengers, some destined for Boston. Everything moved via train then.

The line's difficult terrain reduced its viability and value, as did its surroundings, but its new foothold, a bridge into Manhattan near Yankee Stadium, riled Vanderbilt, who feared competition into Manhattan, acquiring the Put in 1894. In joining New York Central, independence ended, and some Put freight was lost, as New England shippers shifted toward New Haven carriers. Eventually, direct Boston service was discontinued, with a nod from New Haven's Morgan; likely, he was conspiring for greater deals with Vanderbilt.

This became the Putnam division of the New York Central; like the Harlem and Hudson divisions, a semi-self-contained division. The Put ran a viable local freight operation and offered suburban passenger service to 20 municipalities and hamlets over its route.

The Put was remote and was Westchester's rural line, but enjoyed ample clearance space allowing extra-large "dimension" freight and passenger train movements; Army tanks used this route in World War II. The General Motors 1947 *Train of Tomorrow*, with vista-dome cars, made its New York visit via the Put. Some of the rolling stock for the 1939 World's Fair used this route also. The Put, never robust, would in the 1950s through 1980s fade gradually, eventually becoming a bike path.

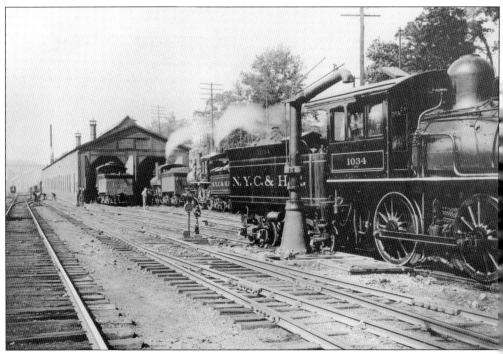

Sedgewick Avenue's engine facility, seen here around 1900, serviced Putnam Division locomotives from 1881 until the end of steam. The engine at right is in New York Central & Hudson River livery. The Put's origin facility was an elongated string of a few tracks, hemmed in by the Harlem River, the Hudson Line, the inevitable hill, and other obstacles. The Put started at Sedgewick Avenue, went through High Bridge Station, narrowing above the BN freight yard at Kingsbridge. (Courtesy of the New York Central System Historical Society.)

This is the Pocantico Hills station in the 1910s. A small yard was kept here, making it the northern terminus of the lower commuter district. This earlier route to eastern Tarrytown closed in 1931, when the Rockefeller family wished to make the neighborhood quieter, funding a shorter bypass through Eastview to Briarcliff. Some of the remnants today serve as hiking or bridle paths in nearby Tarrytown and Rockefeller State Park. (Courtesy of the New York Central System Historical Society.)

EW YORK CENTRAL & HUDSON RIVER RAILROAD.

NEW YORK & PUTNAM DIVISION.

19, 1899.	Mls	521	81	31	1	35	37	39	x41	x5	x43	x7	x45	x47	49	51	529	21	65	69	71	
[LEAVE		AM	AM	AM	AM	AM	Noon	PM	PM	PM	PM	PM	PM	PM	PM	PM	Night	AM	AM	PM	PM	
eet......		†4 00	†5 35	†7 10	†8 15	†10 15	†12 30	†1 35	†3 22	†3 54	†4 15	†4 55	†5 45	†6 20	†8 00	†11 00	†12 00	‡8 25	‡10 30	‡1 35	‡5 50	
t......		4 13	5 48	7 23	8 23	10 28	12 43	1 48	—	—	—	—	—	—	8 13	11 13	12 13	8 38	10 43	1 48	6 03	
e......	0	5 00	6 25	8 00	9 05	11 05	1 20	2 25	4 05	4 33	5 02	5 45	6 31	7 20	8 50	11 50	1 00	9 15	11 20	2 25	6 40	
lt......	1	5 20	6 29	8 04	— —	11 09	1 24	2 29	4 09	— —	5 06	— —	6 35	7 24	8 54	11 54	1 30	9 19	11 24	2 29	6 44	
........	5	5 40	6 38	8 13	9 17	11 16	1 32	2 35	4 18	— —	5 13	5 58	6 42	7 31	9 03	12 03	— —	9 26	11 33	2 36	6 51	
........	8	6 00	6 47	8 20	9 24	11 26	1 43	2 42	4 28	4 49	5 23	6 05	6 50	7 38	9 12	12 11	— —	9 34	11 40	2 44	6 58	
........	11	6 21	6 53	8 26	9 29	11 32	1 49	2 47	4 34	— —	5 30	6 14	6 56	7 44	9 18	12 17	— —	9 40	11 48	2 50	7 09	
........	13	6 30	7 01	8 37	9 35	11 38	1 56	2 56	4 40	— —	5 36	6 20	7 04	7 51	8 24	12 24	— —	9 47	11 55	2 57	7 16	
........	15	6 52	7 06	8 42	9 42	11 43	2 01	3 00	4 45	5 05	5 41	6 25	7 10	7 56	9 29	12 29	— —	9 52	12 00	3 03	7 22	
........	18	7 17	7 16	8 50	9 48	11 50	2 09	3 07	4 57	5 13	5 51	6 33	7 17	8 03	9 37	12 36	— —	9 59	12 07	3 11	7 30	
eights...	20	7 23	AM	8 56	9 52	11 55	2 14	3 12	5 02	— —	5 55	6 38	7 22	8 08	9 42	12 41	— —	10 03	12 12	3 16	7 36	
........	21	7 28	8 59	9 55	11 58	2 17	3 15	6 05	6 19	5 58	6 41	7 25	8 10	9 45	12 44	— —	10 06	12 15	3 19	7 39	
........	22	—	— —	12 00	2 19	3 17	6 07	— —	6 00	6 43	7 27	8 12	9 47	12 47	— —	10 09	12 17	3 22	7 41	
ills.....	23	7 40	9 03	10 00	12 05	2 25	3 22	5 10	5 24	6 05	6 47	7 30	8 15	8 50	12 50	2 40	10 12	12 20	3 25	7 45	
nor....	27	8 00	AM	10 07	Noon	PM	PM	PM	6 32	PM	6 54	PM	PM	PM	PM	Night	— —	10 20	Noon	PM	PM
........	30	8 20	10 13	6 38	7 00	— —	10 26
........	32	8 30	10 17	6 41	7 05	— —	10 31
........	33	8 40	10 22	7 08	— —	10 35
........	37	9 10	10 31	5 50	7 16	3 37	10 43
........	38	9 20	10 34	4 07	6 53	7 19	— —	10 46
ace...	40	9 35	10 38	PM	6 57	PM	7 24	— —	10 51
pac..	42	10 18	10 43	6 02	†7 10	7 29	4 00	10 57
........	44	10 35	10 51	6 08	7 20	7 38	— —	11 08
........	47	AM	10 55	— —	PM	7 42	— —	11 13
........	49	11 00	6 18	7 47	4 38	11 19
Mines...	52	11 04	6 24	7 52	— —	11 25
nction..	54	11 08	6 30	8 00	‡5 00	11 30
[ARRIVE		AM	PM	PM	AM	AM
........	65	11 34	7 00
........	71	11 46	7 12
........	95	12 30	7 58
n.......	114	1 15	8 43
........	119	1 26	8 53
........	128	1 45	9 10
........	245	5 55	PM
[ARRIVE		PM
ime.)		412	x34	x36	x82	x2	38	4	40	42	44	8	46	48	50	524	62	66	68	24	530	
[LEAVE		AM	

N. B.—Time by trains marked x is via Ninth Avenue Elevated R. R. Express Trains. Time for other trains is via Sixth Avenue Elevated R. R.

* Daily. † Daily, except Sunday. ‡ Sunday only. & Saturday only.

Putnam line service was once quite robust to Pocantico Hills; as seen in this 1899 schedule, it offered 16 trains on weekdays, and 10 trains, the bulk of scheduled service, laid over at Pocantico Hills. Just six trains went north then, with four to Putnam Junction north of Brewster station. The faster New York–Boston train service was now in place on New Haven Railroad's Shoreline Route. The two remnants of the former Hartford and Boston link are shown here; they continued until 1907. Running times south of 155th Street reflect the use of the elevated railway. Upper Manhattan's 155th Street Station was closed after 1907. Vanderbilt bought the Put partly to stem competition. He owned Grand Central Terminal, and the link to 155th Street became redundant. After 1907, Put trains instead relied upon Sedgewick Avenue for elevated rail connections, and the nearby High Bridge Station for Hudson Line connections into Grand Central. (Courtesy of the Yorktown Museum & Historical Society.)

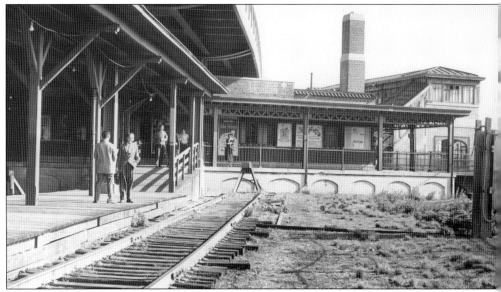

For the Put, Sedgewick Avenue was the southern terminal since Vanderbilt ownership in 1894. The station was basic and placed near the tracks and Harlem River bridge crossing to the 155th Street Station beside Manhattan's Ninth Avenue Elevated, scrapped around 1961. Most passengers used New York Central's nearby High Bridge Station to Grand Central. The Put never had through-GCT train service like the Harlem and Hudson Lines. This meager terminal reveals the railroad's reticent interest in this waning branch's viability. (Courtesy of the New York Central Historical Society.)

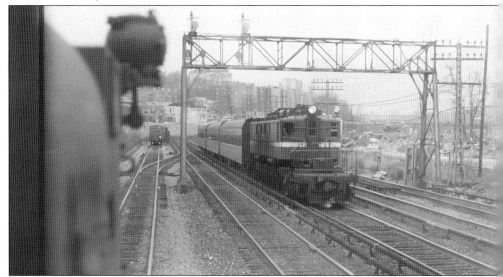

The Putnam division paralleled New York Central's Hudson line to the Bronx's Kingsbridge area south of Marble Hill station, heading north. This 1967 photograph shows a Put reduced to a freight branch and, organizationally, now a portion of the Harlem Division. By now, the track connection was a simple switch to the Hudson line. This photograph was taken when making up a 15-car train to Eastview at the Put's small yard. In passenger days, the Put here was double tracked and had a tower and its busy six-track freight yard. Today, it is a recycling yard. (Photograph by George Kowanski.)

Caryl station was on the 1888-to-1943 Yonkers branch spanning three miles northwest from Van Cortlandt Park to Getty Square via Yonkers Rapid Transit, an NYC&N venture. When the New York Central bought the Put in 1894, its name was homogenized to the Yonkers branch. The hope was that new housing along the route would bring traffic. Ridership peaked at 2,600 in 1937. Early equipment mirrored New York's elevated steam equipment, giving the thought of direct service throughout Manhattan. Instead, New York Central electrified it, but without through–Grand Central service, it never prospered. (Courtesy of the New York Central System Historical Society.)

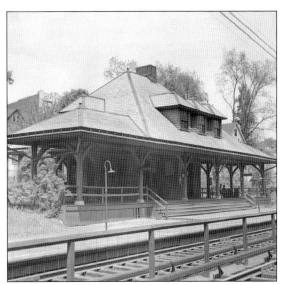

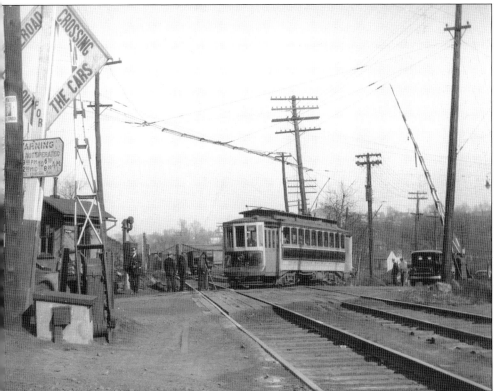

The Put in Yonkers had six smallish, closely spaced stations. Dunwoodie station was on Yonkers Avenue, with a Third Avenue Railway streetcar connection. During the mid-1930s, after this photograph was taken, this crossing was eliminated, placing the road beneath the tracks: it was one of a handful of crossing eliminations on the lightly trafficked Put. Dunwoodie had several freight customers, among them Beers Coal. At one point, coal accounted for about a quarter of local inbound freight in Westchester. Other shippers were at Nepperhan and Gray Oaks. (Courtesy of Herbert H. Harwood Jr.)

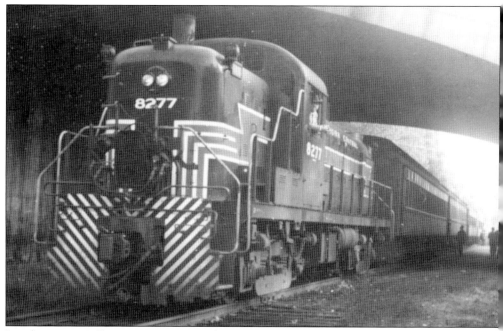

Local teenager Bill Howes, a now-retired CSX vice president, lived near Bryn-Mawr station in 1958 and caught the final run of Put passenger service that May. Yonkers Avenue is overhead. Ridership and the number of trains declined since 1929, when traffic peaked at roughly a million annual rides—3,300 weekday trips. Traffic increased briefly during World War II, but by 1957, only 500 commuters rode the two commuter trains. Some very limited service that involved Harlem division trains from New York to Mahopac, Carmel, and Brewster via Goldens Bridge ran until 1959. (Photograph by William Howes.)

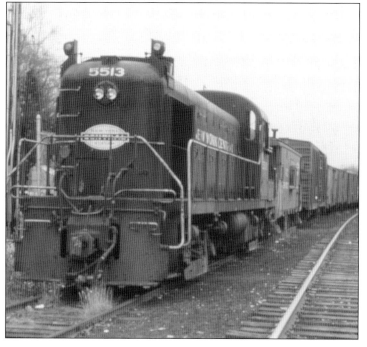

After 1958, freight business held up well through 1975. This BN/BO switcher, denoting Bronx North–Briarcliff, is seen finishing up its Yonkers freight work, about to leave Nepera Park around 1966. The consist has a long-haul caboose, which was rare daily, except on this Saturday assignment. This job lasted until about 1975. Some older ice-loaded refrigerator cars are among those headed for the A&P supermarket warehouse at Elmsford. About 16 cars was the healthy norm. (Photograph by George Kowanski.)

Yonkers is seen in its heyday, with the Allen Carpet Mill on Nepperhan Avenue, the largest freight customer among a cluster of Yonkers shippers in a place nicknamed by railroaders "the hole." In World War II, the mill made tents and uniforms. Phelps Dodge and Grandolfi Lumber were here too. During freight railroading's heyday, this branch and the other dozen or so regular shippers rated their own "Nepperhan switcher." Additional Yonkers customers were near Odell Avenue, Nepera Park, and Nepperhan stations. Today, the carpet mill is an industrial park. (Courtesy of the Hudson River Museum.)

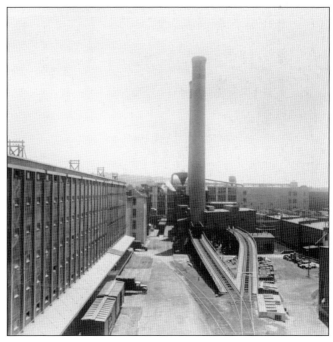

This 1967 waybill for a frozen spinach carload to Kane Miller's Yonkers facility shows an interesting perishable manifest from California via Denver. The Put got almost half of the Yonkers freight, with the remainder along the Hudson line. Put freight customers, in addition to the Alexander Carpet Mill, were Otto-Brehm Flour, Sause-Sea Shrimp Cocktail, and Levine Iron Works. At Chauncey in Dobbs Ferry, Stuaffer Chemical was a shipper; going further back, Children's Village took coal shipments. Some shippers without rail used local team tracks. (Courtesy of Charles McCarthur.)

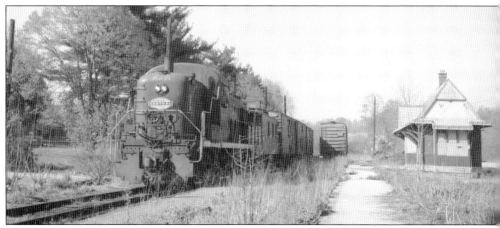

This 1966 Ardsley view shows a boarded-up depot, which was moved from the Dobbs Ferry side of the tracks about 1949 to grade-separate Ashford Avenue. As shown here, a local business used the former second track as a team track to unload a boxcar. The wooden red caboose behind the engine predated World War I and stayed a Put characteristic through 1969. During the 1950s, New York Central invested heavily in diesel locomotives, with modern cabooses not prioritized. The depot, similar to many others unique to the line, was torn down in the 1970s. (Photograph by Richard W. Herbert.)

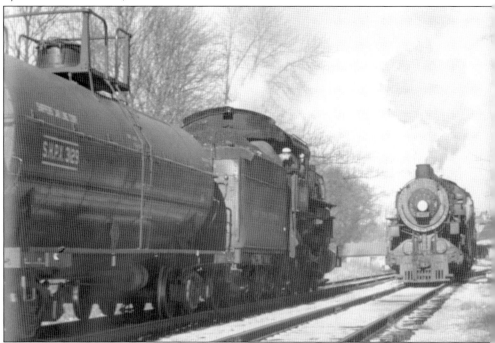

Elmsford was among the handful of more significant stations; its remodeled building is now a restaurant. Here, the northbound freight waits for an eastbound to Sedgewick Avenue local. Numerous stations like Elmsford had a passing siding plus a team track for local freight customers. For steam, the Put relied on ALCO 1910s-built 4-6-0 ten-wheeler passenger locomotives to haul freight, partly on account of the engine's lighter weight. In 1955, a supermarket warehouse came to Elmsford, giving the declining branch a dozen-cars-a-day boost in freight. (Courtesy of the Westchester County Historical Society.)

September 1951 marked diesel power's replacement of steam after a three-month transition. Later, steam left the Harlem line in 1952 and the Hudson line in 1953, ending on the Central in 1957—a 12-year transition. These 1950-built Lima-Hamilton road switchers were among a lot of just 16 engines. By 1955, they would be replaced by newer ALCO RS-3s. The 1950s also marked a shakeout among many rail-equipment makers, especially locomotive makers like Lima and Baldwin, which closed or merged. (Photograph by Richard W. Herbert.)

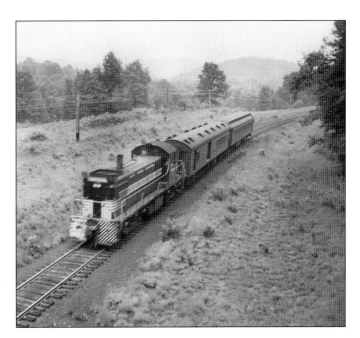

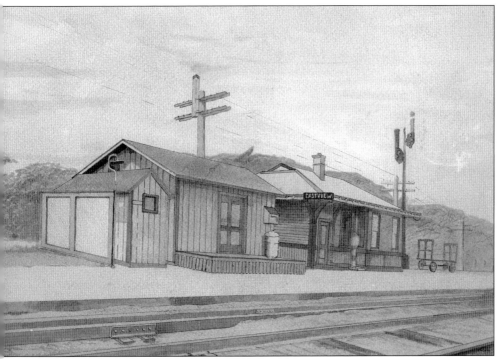

After the Put built its bypass around the Rockefeller estate, this 1931 station at Eastview was built. Eastview was the unofficial operational midpoint. Several freight cars a week would be exchanged here between the two local freights: the daily road switcher from the BN yard in the Bronx and the "as needed" switcher from Brewster's Putnam Junction. A partial 1962 Put abandonment, enabled by expanded car clearances to New York on another line, allowed the abandonment between Eastview and Lake Mahopac, ending the practice. (Illustration by Thom Johnson.)

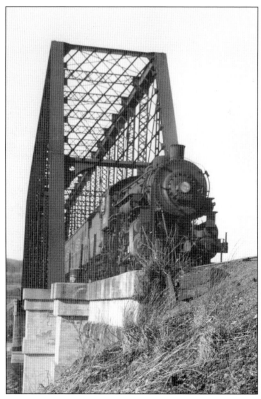

While the Put passed the still-in-place Tudor-style Briarcliff station (now the library), its initial depot was moved to Millwood, and the rare depot was demolished about 2008. The railroad passed flag stops at Kitchewan, Croton Heights, and Croton Lake near Croton Reservoir Bridge, shown here. This location is below Yorktown and is now a scenic point on the county bike path. The bridge never had a heavy weight-bearing capability. (Courtesy of Richard W. Herbert.)

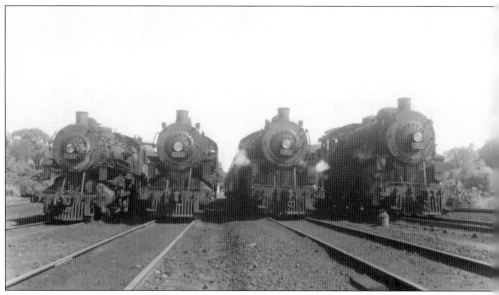

Yorktown Heights had a small five-track yard southwest of the station that generally stabled fou overnight layover and weekend storage trains that terminated here. This April 1948 Sunday viev was available for two decades and was phased out during the 1950s passenger decline. Except fc World War II and its gas rationing, ridership peaked in 1917 with 1.33 million rides. That year automobiles were starting to gain popularity in Westchester, and the first county highway, th Bronx River Parkway, was already being planned. (Courtesy of Richard W. Herbert.)

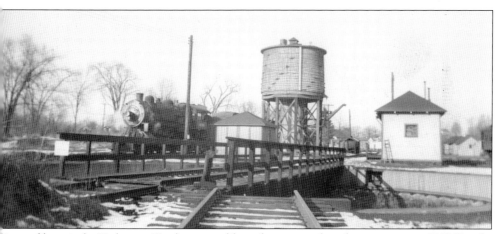

Pictured here is the Yorktown Heights turntable with spare track and water spout in 1948. Freight traffic became light on the northern end above Elmsford, where hamlets were sparsely populated. Also, by this time, trucking had taken over most local freight traffic, further thinning this upper Putnam line's freight base. A local freight by this period operated three times weekly from Putnam Junction to Eastview; that frequency diminished until this middle segment was abandoned in 1962. (Courtesy of Richard W. Herbert.)

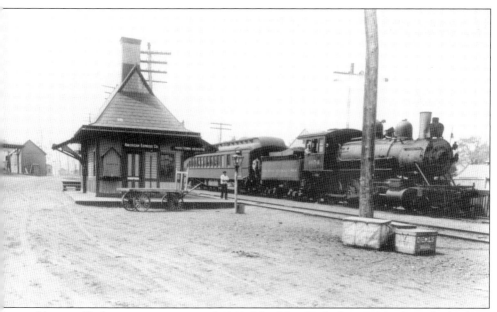

Pictured here is Yorktown station around 1910. The New York City & Northern built about nine similar stations, some with variations, such as larger buildings, where needed. A number of other designs were built, but this was the most typical. Yorktown, as of this writing, has the last such intact station. This train shows an open vestibule combination car and 4-4-0 engine 354, typical of the small but fast engines. By the early 1930s, all but one of these 4-4-0s was replaced by newer and larger 4-6-0 engines; both were ALCO products. (Courtesy of the Yorktown Historical Society.)

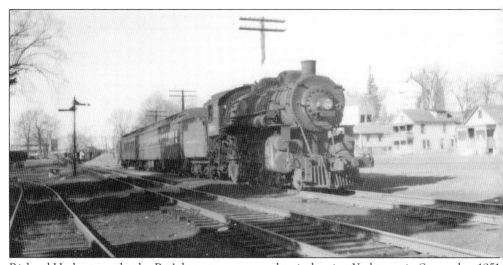

Richard Herbert caught the Put's last steam-powered train leaving Yorktown in September 1951. Modernity eluded this rural anomaly. Kerosene lanterns and outhouses were still used here. Coal still heated stations. Nine new diesels replaced 13 steam engines, but new motive power was not an investment, but rather an economy measure. Upper management was likely quietly discussing the Put's eventual demise by this point. The great New York Central was reeling from general declines in traffic caused by new competition from cars, planes, and trucks. (Photograph by Richard W. Herbert.)

Seen here is a typical small Put station interior. Most Put depots were wooden and had coal stoves up to the end of passenger service in 1958. Telegraphy also continued, as no money was spent on phones. Many believed that some among railroad management saw the lacking utility and profitability of the Put, perhaps dating to the 1920s, when motorized vehicles began their competitive presence in a county that was ideal for them at that time. Since then, the population over the Put's route has quadrupled since its heyday, raising the possibility that a restored Put might work again. (Courtesy of the New York Central System Historical Society.)

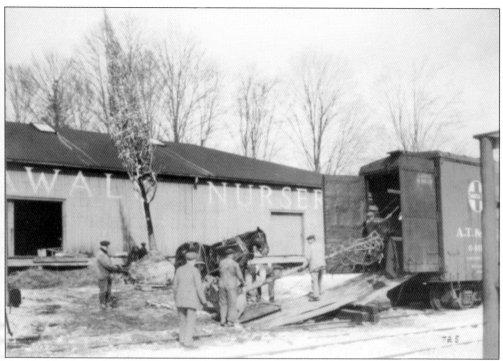

Amawalk, a mile above Yorktown Heights station, had Amawalk Nursery, which shipped trees West and a Christmas tree to the Calvin Coolidge White House. Other produce, such as apples or Mahopac peaches, went to New York City before the motor age. Several farms new and old can still be found near the Put's route—Stuarts, Hanover, Sundial, Tilly Foster, and Meadows, among the last of the large county farms. (Courtesy of the Yorktown Museum & Historical Society.)

Photographer Bill Howes, then in high school, rode Bryn Mawr to Granite Springs and back in the summer of 1956, the final year one could ride the Put to northern Westchester and return on a day trip. The Put's schedule thinned through the 1950s from over a dozen trains throughout the day down to two in the final year. (Courtesy of William Howes.)

This photograph of the Ardsley Station, seen in its later years, shows the very last Put passenger train during an October 1967 excursion to Eastview, just completing its photo run by. Ardsley kept busy in the passenger years, counting 130 daily commuters as late as 1956. Station agent Fred Arone Sr. was a village denizen: he was a reporter for the local newspaper and sold real estate. It was not unusual for small-town station agents to have several part-time ventures to get by. The foreground barely reveals the once grade separated Ashford Avenue. Conductor Armando Perri is at bottom center. (Courtesy of Thom Johnson.)

Seen here is a fireman's view of Bryn Mawr Park. This bridle path view can still be enjoyed via foot or bike on the Westchester Bikeway, which covers most of the Put route. Bryn Mawr Park was also on the toughest hill and grade for Put freight trains, often requiring westbound trains over 15 cars to "double the hill"—making two trips to bring the train above Yonkers. Bikers and hikers should be warned of some grades. This old route has places to eat or even get a bike. There is even room to rebuild the old Put again when needed. (Photograph by George Kowanski.)

Seven

STREET RAILWAYS AND MISCELLANEOUS

Streetcars, or trolleys, met transit needs in Westchester's busier villages and cities beginning in the 1880s, initially with horse cars. An early example could be found in Wales in 1807; this region's first was in 1832—the New York & Harlem horse operation.

In 1888, Connecticut inventor and US Naval Academy graduate Frank J. Sprague perfected electric trolley technology with an electric motor and rail refinements such as regenerative braking, multiple-unit operation, and the spring-loaded trolley pole; he eventually sold his firm to Thomas Edison. Electric trolleys became a practical mode of transit, soon replacing horses, and over 100 trolley lines operated nationally, starting a trolley boom.

Westchester street railways started as small independents but soon narrowed to essentially two large companies, although the industry was chronic with financial malaise. Westchester's streetcar history was complicated and tedious. It was a saga of lack of capital, anemic revenues, and never prospering—a reason for creating transit agencies. Most streetcars remained at and below today's I-287 corridor, with added service near the Bronx.

In the north part of the county, two small-town operations in Ossining and Peekskill met municipal transit needs. Early streetcars generally ventured several miles from town to a destination such as an amusement park, a beach, or a new development.

The more urban, southern part of the county had the most lines. Independent street railways eventually merged into two large operators. The Third Avenue Railway System (TARS), established in 1852, eventually acquired Yonkers Railroad and additional companies by about 1900. Simultaneously, the eastern county's street railways instead became a New Haven fiefdom in J.P. Morgan's empire as the New York & Stamford Railway and Westchester Street Railway. The county, unfortunately, was also well suited to motor vehicles, and when the trolley boom flourished, few conceived of the real future of motor cars and buses that would soon begin banishing streetcars in the 1920s through simple route conversions to buses, often conducted by those street railways. The TARS Yonkers system was a holdout until 1952.

Today's County Bee-Line system and Metropolitan Transportation Authority can claim lineage to the streetcar. In modern parlance, "light rail" is now the common word. While absent from this region, streetcars are making comebacks in Philadelphia, Denver, California, and elsewhere. In Europe, they never left service. Streetcars have a great efficiency of moving people comfortably in crowded urban areas.

This chapter concludes with some miscellany such as special trains, temporary construction railroads, and never completed railways.

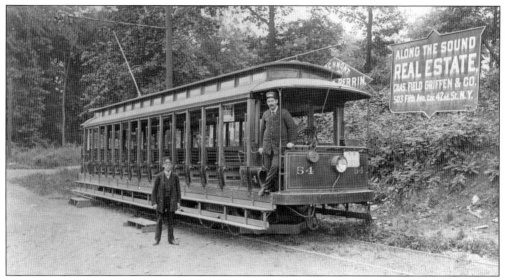

Westchester's first street railway, the Larchmont Horse Railway, began in 1888 with a couple of miles of track. This c. 1900 photograph illustrates new electrified service in a still-wooded area near the New Haven station, with billboards beckoning passing train passengers to live here. Larchmont's Dutch and French beginnings were in about 1616. When the New Haven Railroad came in 1848, attractive coves for boaters turned this hamlet into a busy resort village. Affluent residents came seeking the 40-minute commuting lifestyle, linking city and pastoral suburbia. (Courtesy of Robert A. Bang.)

This TARS Brill-built streetcar evolved from the first stagecoach-type car, atop rail bogies, as shown on page 12. This early 1900s electric car culminated from Sprague's refinements. The car lasted until the late 1940s. A 1930s TARS economy in-house building of newer all-steel streetcars drew upon cannibalized parts from older equipment. This program was cut short in the face of late 1930s New York City bus conversions. (Courtesy of Robert A. Bang.)

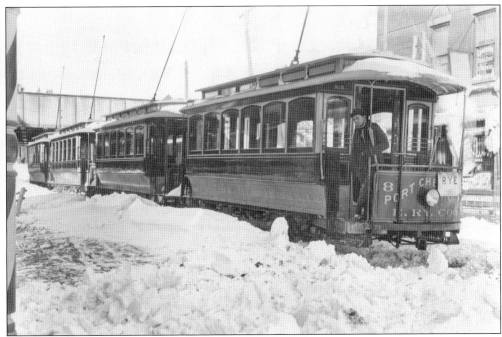

The trolley-lettered Port Chester Electric Railway is not yet painted to match its merged New York & Stamford Railway; it is seen in 1907 near its namesake station. New Haven/Morgan–owned trolleys were a somewhat extraneous asset. Even the White Plains–Tarrytown line was acquired by the New Haven. Morgan and Charles Mellon likely overpaid, a characteristic of their feverish purchasing to ward off possible competition, which was unlikely anyway. However, the psychology of those times seemed to suggest otherwise. (Courtesy of Robert A. Bang.)

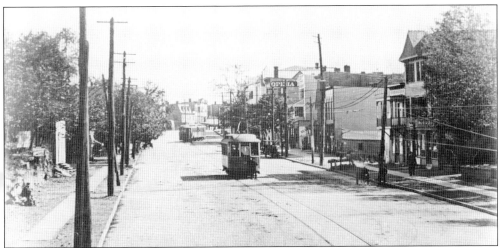

Mamaroneck, as a stop on the New Haven–owned New York & Stamford Railway, also had a line to White Plains. The service design also served a New Haven rail feeder. With the 1912 NYW&B startup, emphasis included feeding the NYW&B stations. By the mid-1920s, a post-Morgan New Haven Railroad was fast to convert to bus, pairing a costly operation and renaming it County Transportation Company, which lasted through the 1950s. Conversely, trolley-oriented management at TARS continued running numerous trolley routes. (Courtesy of Robert A. Bang.)

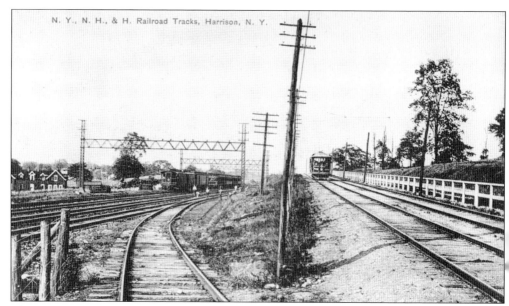

J.P. Morgan's New Haven Railroad, at left, paralleled his subsidiary New York & Stamford Railway on faster off-street trackage near Harrison. Similar trolley subsidiaries in Connecticut linked with numerous affiliated lines in New England. Historian J.W. Swanberg cites New Haven's massive and overpriced purchasing of trolleys lines as perhaps the largest underlying cause in New Haven's 1935 bankruptcy, which hastened distress sales or closure of most subsidiaries. (Courtesy of Robert A. Bang.)

The New York, Elmsford & White Plains Railway also served Tarrytown from Elmsford and White Plains beginning around 1897, replacing a stage. Shown is Elmsford in the 1920s, joined with the renamed Tarrytown, White Plains & Mamaroneck Railway, typically experiencing the confusing series of ownership, with transactions often done to mitigate money problems. Owners were the Union Railroad and Westchester Street Railroad, and then another distress sale to a not-rich TARS in 1898. After that brief ownership, a similar fate again expedited operation into the New Haven sphere in 1910. (Courtesy of the Westchester County Historical.)

This is a view from the White Plains–Tarrytown road. Despite the financial difficulties, the Tarrytown–Elmsford–White Plains line was a busy route, remaining so under the county Bee-Line system today. Capital costs and a maintenance-intensive operation hampered financial viability. Highway/rail maintenance problems were an issue too, as county highway authorities encouraged bus conversions, which New Haven obliged in 1928 with a better bus schedule. This view is believed to be east of Tarrytown. (Courtesy of the Westchester County Historical Society.)

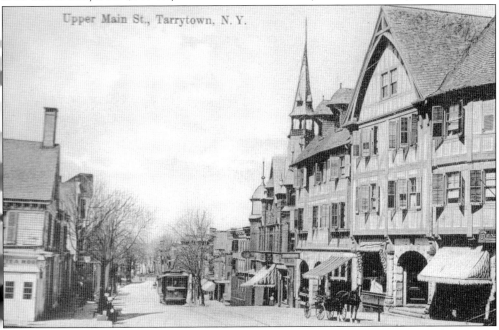

A New Haven–owned operation reached Tarrytown, with the route climbing from the river up the stiff grade from the train station, as seen here on Main Street near Albany Post Road. The Tarrytown–White Plains–Port Chester corridor continues to be discussed as an ideal light-rail corridor if given a dedicated right-of-way. The I-287 corridor was studied as a component in a possible Tappan Zee–Grand Central route. For a brief period, a Tarrytown-Yonkers line was planned by the Yonkers Railroad, later TARS, but it faded by the 1910s. (Courtesy of Robert A. Bang.)

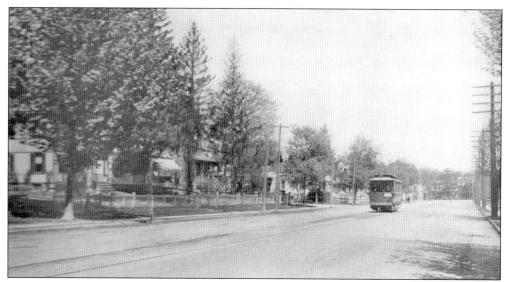

This mostly residential view of Mamaroneck Avenue in White Plains in 1902 is another example of how that road's level terrain, lighter grades, and gradual curves had some of its construction built around the streetcar right-of-way. As the county seat and only sizable city north of those abutting the Bronx, the city long had an urban feel. While White Plains never had the extensive street rail network that Yonkers once had, three streetcar lines served key city approaches from East Harrison, Tarrytown, and Mamaroneck. By 1929, trolleys here were retired. (Courtesy of Robert A. Bang.)

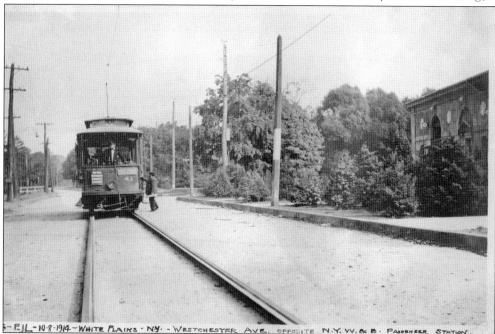

Two New Haven transit operations in White Plains—the New York, Westchester & Boston Terminal at right, served by sister firm Westchester Street Railway at left—allowed transit-oriented development in West Harrison's Silver Lake, advertising streetcar access to downtown White Plains and two stations. Real estate developers often promote rail access as a convenient feature of properties. (Courtesy of the Westchester County Historical Society.)

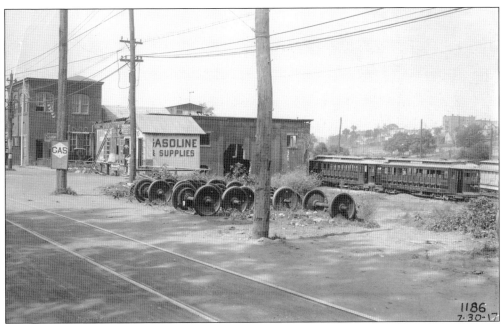

Both photographs show the White Plains car barn on Central Avenue, south of today's Westchester County Center. At far right above is the Harlem line by the hill in July 1917. Note that the streetcars are summer-modified, with winter paneling removed. The varnished cars read "Westchester" for the Westchester Street Railroad. Below, photographed on the same day and just away from Central Avenue, weeds, building damage, and streetcars out of service at right reveal hard times, even under New Haven stewardship since 1910. In just a decade, buses would replace these streetcars. The disused cars at right appear to have been painted or decorated for an unknown event, perhaps a film shoot. This region had a small pre-Hollywood silent film industry. (Both, courtesy of the Westchester County Historical Society.)

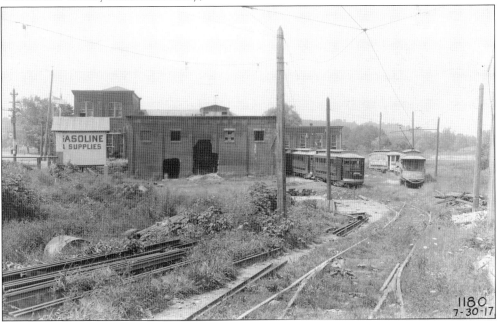

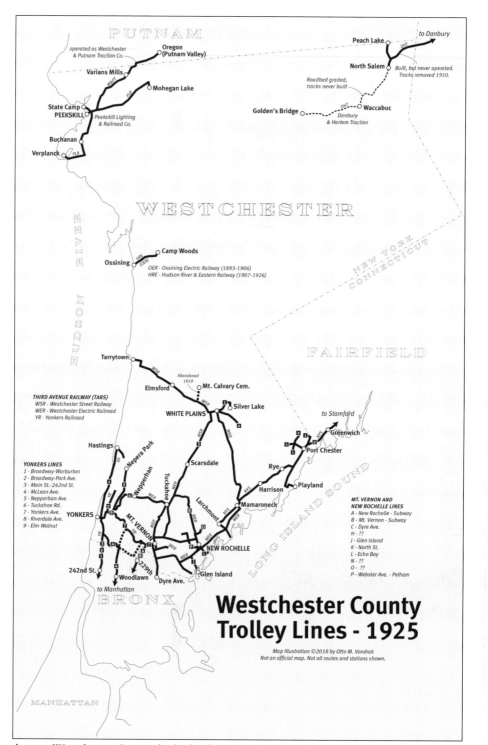

Westchester County Trolley Lines - 1925

Map Illustration ©2018 by Otto M. Vondrak
Not an official map. Not all routes and stations shown.

PUTNAM

operated as Westchester & Putnam Traction Co.

Oregon (Putnam Valley)

Varians Mills

Mohegan Lake

State Camp
PEEKSKILL

Peekskill Lighting & Railroad Co.

Buchanan

Verplanck

Peach Lake

to Danbury

North Salem

Built, but never operated. Tracks removed 1910.

Roadbed graded, tracks never built

Golden's Bridge

Waccabuc

Danbury & Harlem Traction

WESTCHESTER

HUDSON RIVER

Camp Woods

Ossining

OER - Ossining Electric Railway (1893-1906)
HRE - Hudson River & Eastern Railway (1907-1926)

NEW YORK
CONNECTICUT

FAIRFIELD

Tarrytown

Abandoned 1919

Elmsford

Mt. Calvary Cem.

Silver Lake

WHITE PLAINS

to Stamford

Greenwich

THIRD AVENUE RAILWAY (TARS)
WSR - Westchester Street Railway
WER - Westchester Electric Railroad
YR - Yonkers Railroad

Port Chester

Hastings

Nepera Park

Scarsdale

Rye

Playland

YONKERS LINES
1 - Broadway-Warburton
2 - Broadway-Park Ave.
3 - Main St.-242nd St.
4 - McLean Ave.
5 - Nepperhan Ave.
6 - Tuckahoe Rd.
7 - Yonkers Ave.
8 - Riverdale Ave.
9 - Elm-Walnut

Nepperhan

Tuckahoe

Harrison

Mamaroneck

YONKERS

Larchmont

MT. VERNON AND
NEW ROCHELLE LINES
A - New Rochelle - Subway
B - Mt. Vernon - Subway
C - Dyre Ave.
H - ??
J - Glen Island
K - North St.
L - Echo Bay
N - ??
O - ??
P - Webster Ave. - Pelham

MT. VERNON

NEW ROCHELLE

242nd St.

229th

Woodlawn

Dyre Ave.

Glen Island

to Manhattan

BRONX

LONG ISLAND SOUND

MANHATTAN

Rural upper Westchester County had a few lines, but the urban lower county needed a more robust streetcar system. Around 1910, motor vehicles started taking over. Municipal governments and county residents pushed for bus conversions by the 1920s. (Map by Otto M. Vondrak.)

Crews for Ossining Electric Railway, established in 1893, are seen here. It was a typical small-town effort; with electric optimism, two routes served the village. One was a branch to Sparta Hill, with the main route from the station and local industry threading up through the village heading northeastward east of Broadway to Ossining's Methodist campground. Big plans were underway, as a line was envisioned to prospering Briarcliff, Pleasantville, and White Plains. Ossining Electric's second and last owner also operated the Danbury & Harlem Traction Company. (Courtesy of the Westchester County Historical Society.)

Ossining generated revenues barely covering operating costs, leaving little for maintenance or debts from construction, a common problem in the transit business. A 1906 service hiatus precipitated by an unaffordable powerhouse repair bill caused abandonment until Hudson River & Eastern rebuilt it about 1909. The new franchisee also operated trolley services in Danbury, and owners dreamt of an Ossining-Danbury service. This service was sold and converted to bus under Westchester Coach in 1926. (Courtesy of the Westchester County Historical Society.)

DIVISION STREET LOOKING TOWARDS POST OFFICE

The Peekskill Electric Railway Company was a subsidiary of its namesake local power provider. Built initially as a smaller city railway to Mohegan Lake five miles east in 1899, it too started as a starving independent, Peekskill Traction Company, and was soon bought by Peekskill Electric. Extensions reached into Putnam Valley and Verplanck. Bus conversion came in 1924–1926. Interestingly, its bus company descendant remained independent until 1978. Traces of the former right-of-way can be found in remote areas. (Courtesy of the Westchester County Historical Society.)

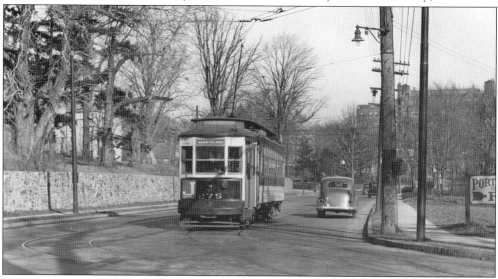

The Glen Island Trolley, shown here, ran until 1939 from the popular Glen Island Casino to New Rochelle station. New Rochelle was the northeast terminus of TARS, sharing the terminal with the other large county operator, the New York & Stamford Railway. The Third Avenue Railway System operated former Westchester Electric Railway lines in New Rochelle and Mount Vernon, and the former Yonkers Railroad served the Bronx and Manhattan. TARS management did not seem as anxious as some other carriers to use buses, but a late 1940s reorganization changed that. (Courtesy of the Westchester County Historical Society.)

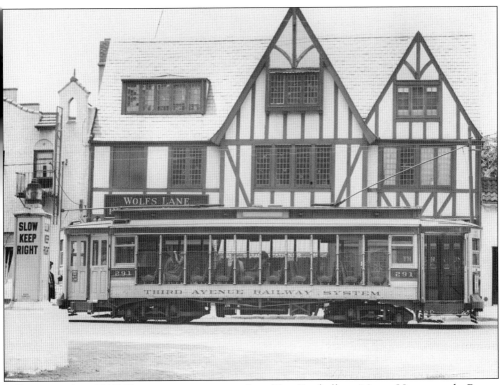

Pelham was along TARS's eastern-county route from New Rochelle to Mount Vernon and a Bronx subway connection at 229th Street, its longest in Westchester. Technically, the carrier name was still Westchester Electric Railway, a subsidiary of TARS. Decades of complicated franchise arrangements, leases, and contracts often meant that antiquated agreements were kept in place. Such legalities helped to confound and delay the last trolley closures in the 1940s and 1950s. (Courtesy of the Westchester County Historical Society.)

New Rochelle shows a TARS Webster Avenue car in the late 1930s. Trolleys in southern Westchester offered an economical steel rail commute when combined with New York City subways. Subway-dedicated trolleys remained popular to their 1950s end and were the last streetcars to exit Westchester. (Courtesy of the Westchester County Historical Society.)

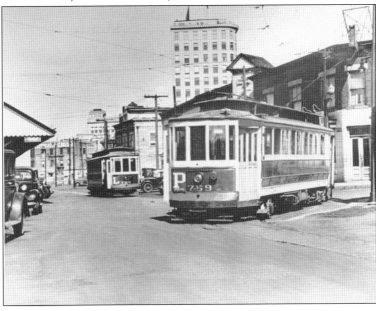

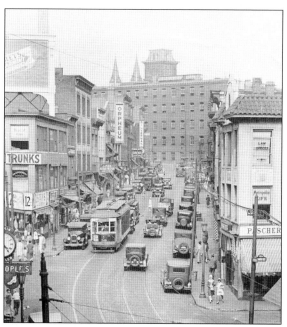

Yonkers, seen in the 1920s, started running trolleys in 1896 as the Yonkers Railroad Company, even holding a charter for the never-built Yonkers & Tarrytown Electric Railroad. TARS soon acquired the operation, where a robust nine routes radiated from downtown Yonkers to Hastings, Mount Vernon, a Bronx subway terminus, Manhattan, and key street routes. While New York City pro-motorbus politicians mostly rid trolley routes by the late 1930s, south-county municipalities did not appear as anxious, as streetcars tended to outlast their neighboring counterparts across the Bronx border. (Courtesy of the Yonkers Historical Society.)

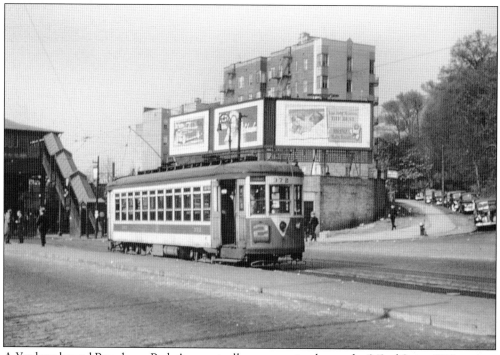

A Yonkers-bound Broadway–Park Avenue trolley connection leaves the 242nd Street IRT station, where routes ran until late 1952. Mount Vernon and New Rochelle also had feeder lines to the Bronx subways until 1950. Such holdouts stayed as busy corridors. These routes that ventured a couple of miles into the northern Bronx were also that county's last streetcars. Some retired trolleys were sold to Vienna, Austria. A handful of TARS cars survive at museums, such as the Shoreline Museum in Connecticut and the Kennebunk Trolley Museum in Maine. (Courtesy of Otto M. Vondrak.)

Narrow-gauge construction railroads were the big-earth movers prior to motorized construction vehicles. The locomotives, cranes, and mostly hopper cars were narrow gauged for portability. Construction railroads helped build the Panama Canal, 1913's Grand Central Terminal, and several Westchester projects, notably hauling quarry stone for the Croton and Kensico Dams in the 1880s. The New York, Westchester & Boston used construction rail equipment for this temporary trestle near Pelhamin about 1910, filling earth for the actual railway. (Courtesy of the Westchester County Historical Society.)

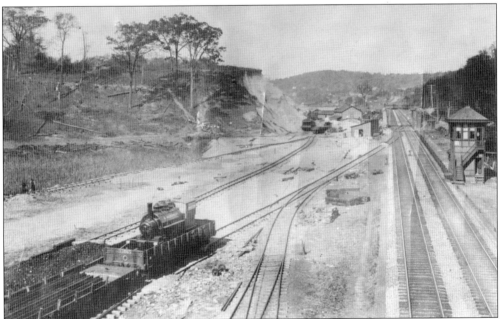

In this c. 1910 photograph, Croton-on-Hudson was still a minor stop, but Harmon yard construction was underway. Croton Point's earth-capped sand dune is seen being cleared. The area of the former two-track Hudson River Railroad, now part of the New York Central & Hudson River Railroad, is being leveled to accommodate the new electric equipment shop and yard. The Central mainline here grew to four tracks, and storage/running tracks braced the mainline for expanded capacity and flow. (Courtesy of the Croton-on-Hudson Historical Society.)

Special trains sometimes visited the county. Near the eve of the 100th anniversary of America's transcontinental rail completion, in May 1969, the *Golden Spike Centennial Special* traveled from Grand Central Terminal to Promontory Point, Utah, where another special train from San Francisco met it for ceremonies. The train is shown leaving Croton-Harmon after swapping from electric to steam power. The locomotive is a Nickel Plate Road Berkshire-type 2-8-4, built for fast freight service in the Ohio region, seen accelerating west amid many onlookers. (Photograph by Harry Nestle, courtesy of Croton Historical Society.)

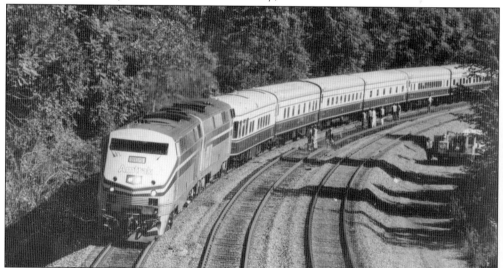

The American Orient Express was a rail-cruise operator similar to several other operators in North America. This train approaching Route 9A in Cortlandt Manor in 1997 used Croton-Harmon as its Westchester stop, where the passengers visited several historic Hudson Valley venues including Washington Irving's Sunnyside, Van Cortlandt Manor, Stone Barns, Boscobel, Philipsburg Manor, and the Kykuit-Rockefeller Home. The train's luxury consist was hauled by Amtrak power and included a former *20th Century Limited* observation car. (Author's collection.)

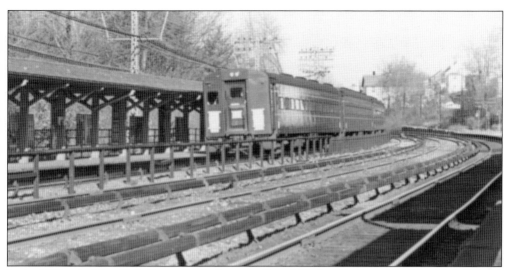

In the 1960s, the New York Giants football team still used Yankee Stadium. The New York Central ran the *Giants Football Special* to Melrose station in the Bronx, where buses met the train. Here, the *Special* is going through Crestwood in its older pre-1970 track layout, giving Crestwood the look of a four-track Harlem line in mid-Westchester. The train consist is of 1962–1965 Pullman Standard–built MU cars, used until 2007, when Metro-North was able to retire these with their newer M-7 Bombardier cars. (Photograph by John Springer.)

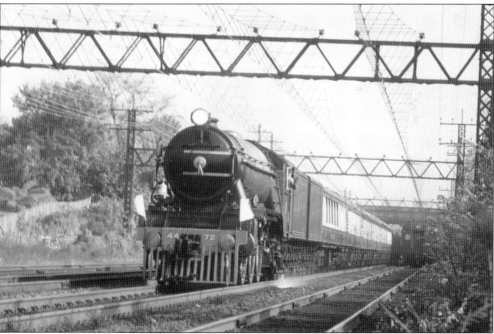

In 1969, the famous former British Railways *Flying Scotsman*, using a full car-set with a famed fast locomotive—LNER Class A3 class, 1934-built 4-6-2 speedster—passes near Harrison. The engine, retired in 1963, was saved from scrapping by Alan Pegler and still makes trips for Britain's National Rail Museum. Until the 1980s, most railroads still had veteran employees familiar with steam engines, making such steam visits easier for rail carriers. A New Haven local is seen at right. A new *Flying Scotsman* still runs from London to Edinburgh. (Photograph by Amos G. Hewitt Jr.)

The county had several unfinished, or never started, rail projects running out of capital in their early days before substantial work was completed. Remaining from the early 1900s is Harrison's bridge abutment, built for the New York & Port Chester Railroad, William Gottshall's subway-compatible transit railway that was stifled by Morgan in favor of the NYW&B. Numerous such unbuilt railroads are detailed in the book *Forgotten Railroads of Westchester*. (Courtesy of the Westchester County Historical Society.)

Today, a North Salem bridle path follows the former trolley route of the Danbury Traction Company, which built the line southwest into Westchester, track-tested for just one day around 1902, and then abandoned the venture. North Salem also hosted the Westchester Northern Railroad, a never-built freight line that would have been a New Haven–owned freight trunk from Danbury to White Plains, continuing over NYW&B tracks south at off-peak times. About a dozen other county railroads never got past proposal stages, including the New York, Housatonic & Northern; the Peekskill & Carmel; and the Rye Lake Railroad. (Author's collection.)

Eight

WEAR AND DECLINE

The 1800s railroad investors never realized how motorized vehicles would take so much of their freight and passenger traffic. It was a trend over a century long, not noticeable in 1919 when national rail miles peaked. America, with seven million highway vehicles at the time, also saw road paving begin in earnest. The Great Depression hurt revenues, then railroads were pressed hard during World War II. Afterward, railroads lost business to new highways, then airplanes.

Suburban growth increased rail commuter patronage after the war, but the underlying financial health of Westchester's two railroad companies started failing. Their rolling stock and plant were worn. Local freight customers had been gradually shifting to trucking. The region's manufacturing base began declining.

Consumer goods for the county began a shift to the larger distribution centers in New Jersey; hence, they were trucked to Westchester. That trend continues today. Hundreds of trucks now come into Westchester, making longer trips from distant mega warehouses, versus more localized distribution facilities, giving rise to the question of how much of the cost goes to transportation. A logistics-savvy entrepreneur might be able to develop a method to bring viable rail freight back to the region by enhancing local distribution methods.

The decline came to a head in the 1970s and 1980s, a period of cynicism for railroaders, with financial problems, derailments, breakdowns, mishaps, and tired trains limping along. Railroad employees fought to keep trains running and mostly did—sometimes with duct tape and baling wire. Passenger expectations were much lower, with few now seriously expecting their train to be clean, on time, or temperature-controlled. Lack of seating was an even worse rush-hour annoyance.

These problems would be largely addressed incrementally, as the legacy railroads were reformed after 1983. The county's former New York Central and New Haven railroads were merged into Penn Central Company (PC), which soon became the largest rail bankruptcy in June 1970. With Connecticut's involvement as a stakeholder, New York State's MTA gradually began involvement with help, plus oversight, evolving into Metro-North Railroad (MNR) in 1983. MNR began a multi-decade effort to return quality rail service to Westchester's three commuter lines. Conrail took over the remaining freight business, later ceding to CSX and Providence & Worcester Railroads.

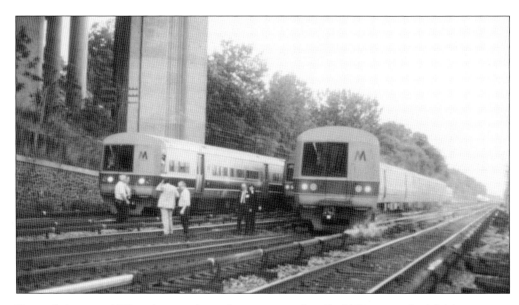

Pictured above is a 1978 mishap involving then-commonplace Budd Company–built M-1 commuter cars. One car is on two adjacent tracks beneath the Tappan Zee Bridge. From left to right are master mechanic Ed Whitney, road foreman Pete Hansen, trainmaster John Kaplan, and conductor Patricia O'Leary. This incident caused a multi-train backup. The affected train, which nicked a smoking third-rail nose piece, was backed up and sent to Croton-Harmon's shop. Below is the winter 1974 Crugers wreck of Amtrak train No. 78 from Buffalo, which then still relied upon Penn Central to operate the train during its darker days. An ancient steam crane re-railed the coaches at right. The Northeast rail decline required congressional intervention, and by 1976, congressionally mandated Conrail was formed. Passenger and commuter issues were to be addressed in the fullness of time. (Both, author's collection.)

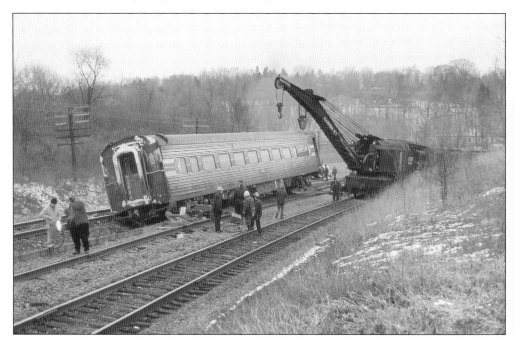

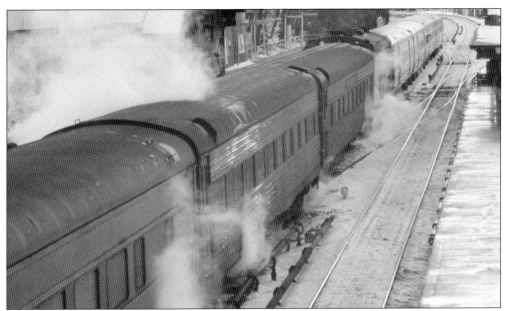

Most Northeastern railroads were still in distress when this 1982 photograph was taken by the author during a signal failure at Glenwood tower. At this point, freight railroads were recovering but downsizing. However, commuter operations were at a low point. Winters were harsh on operations. Here, a Harmon–New York express was disabled on this frigid morning, compounding problems. A Poughkeepsie–New York express coupled on and eventually shoved the disabled train to Yonkers station. At this time, plans were underway to make major improvements, but they would take several years. (Author's collection.)

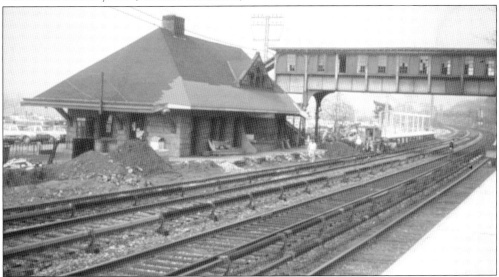

At Dobbs Ferry station in 1973, a raised four-car platform in the distance is readied for the new 180 Budd–built M-1 MU commuter cars. The station, like many, required some depot disfigurement, allowing a new raised eight-car platform. This project was done after Harlem and New Haven line stations received similar work. These were pre–Metro North days; however, the MTA by now was helping the ailing commuter operation, contracting with Penn Central and then Conrail from 1976 through 1983. (Photograph by Kent Patterson, courtesy of the Dobbs Ferry Historical Society.)

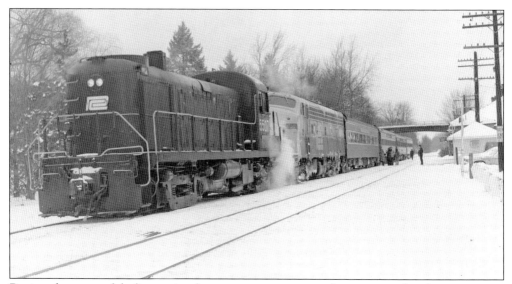

During the years of decline, aging locomotive power assisted in covering local train service. Borrowed locomotives came from Conrail, Amtrak, and New Jersey Transit. This venerable ALCO RS-3, technically retired from passenger work, was again found pulling passenger trains in the 1970s under adverse circumstances. The railroad's motive power situation was abysmal. Above, Alan Gruber, then a tower director, brought his camera to work in the snow, photographing this early Conrail scene with an RS-3 still in PC livery lugging a disabled FL-9 in consist on Gruber's train to work in 1977. Below, similar engines were again needed to assist dilapidated rail diesel cars, built as self-propelled for economy. There was no economy in this photograph taken north of Peekskill in the Hudson Highlands near the Fort Montgomery Tunnel. When Metro-North took over all the Westchester lines in 1983, dispatching trains with adequate and reliable engines was a continual operating difficulty into the late 1990s. The longtime problem was finding a manufacturer of reliable dual mode electric-diesel-type locomotives. (Above, photograph by Alan Gruber, below, author's collection.)

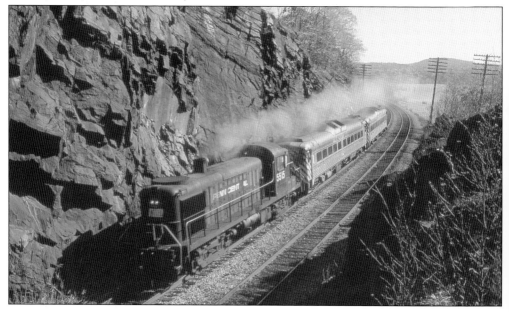

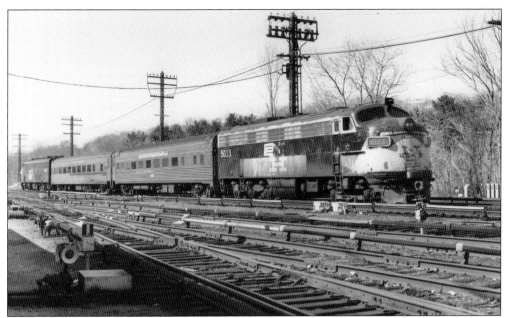

Another practice in the 1970s and early 1980s during the chronic equipment shortages was making up an oddball consist like this, with two coaches sandwiched between engines in order to cover diesel service north of Croton-Harmon and North White Plains prior to Brewster electrification. The problem here was habitually absent self-propelled RDCs, requiring this default arrangement. This type of train was costly to operate and clumsy. However, it could make a quick turnaround at terminals and was at least able to move people close to schedule. New Bombardier push-pull coaches were still several years off. (Photograph by J.W. Swanberg.)

Esteemed conductor and *20th Century Limited* veteran David Spellman is seen here helping passengers on an Amtrak train from Buffalo in 1972; it was an example of the "people factor" that saved passenger railroading amidst apathetic management in the 1960s and early 1970s. Most railroad executives aspired to freight work, since it was profitable, while a passenger career was an oxymoron. Yet, aboard passenger trains, engineers, conductors, car attendants, waiters, chefs, red-caps, mechanics, and others still took pride in working hard to maintain service despite management trying to eliminate them. (Author's collection.)

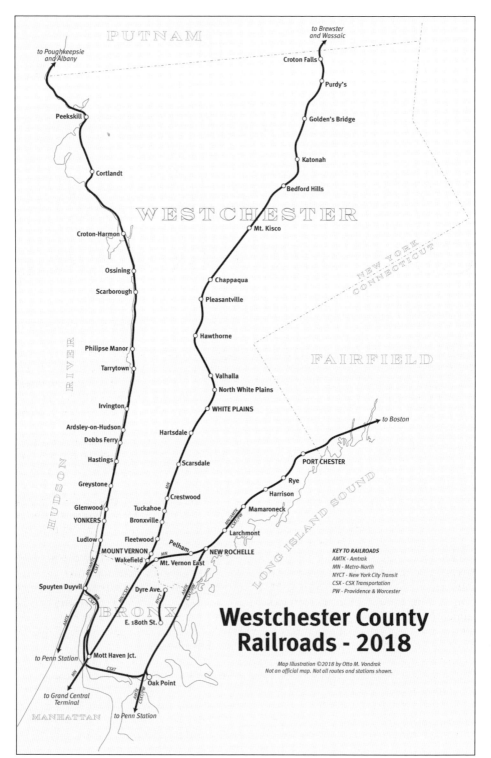

Compare this map with the 1930 version on page 10. Half of the tracks are gone, along with the streetcars. However, the remaining lines are still very busy. (Map by Otto M. Vondrak.)

Nine

TRANSITION TOWARD CONTINUED IMPORTANCE

In some respects, the railroad era has passed, as planes, trucks, cars, and even mail sorting machines have replaced much of railroads' once-important functions.

Yet rails expedite millions of tons of lumber, recyclables, food, and ore, plus over 100 million passengers and commuter rides were counted in recent years, increasing since the 1970s after a protracted post–World War II decline. Just imagine how much worse road congestion would be without railroads or rail transit. In a sense, they are a means for getting about without a constant traffic jam. Westchester County's traffic issues are rather decent when compared with non-transit urban areas.

Numerous cities and suburban areas are now returning to transit, even designing municipalities around both foreseeable and conceptual rail and transit use. Some key Bee-Line bus routes may someday convert to light-rail routes. An electric railroad right-of-way can be as narrow as 19 feet—quiet, landscaped, and even between lines of houses in a nice neighborhood. While the trend toward green buses, a smokeless streetcar virtue, is a welcome improvement, rail gives a more comfortable ride; plus, a single track can do the work of four traffic lanes. Via railroad transit, one can eat, sleep, walk, or work instead of driving. The millennial generation, with its new transit habits, seems to have learned that driving is inefficient.

Ideally, routes should be designed for high usage, with a good fare recovery that will not burden taxpayers yet be affordable to all. However, building such projects are daunting, with price tags in the millions or billions. But it also seems that waiting to build such projects has its own cost in stressing existing infrastructure and services, which is evident today with Pennsylvania Station's desperately overdue added-tunnel project. Westchester's Tappan Zee Bridge, another example of transit intransigence, was first proposed to have rail, but rail was rationalized out to save costs. Will that rationale bring hidden costs to the lifestyle of the future?

Freight has effectively left county rails, except for some traffic destined south of Westchester. The three rail lines should accept some long-haul freight since voluminous consumer goods are delivered here by motor haulage.

Railroads aid commerce in downtown renaissances, such as in Miami, Florida, and even Harrison, New Jersey. Here, New Rochelle, Port Chester, Tuckahoe, White Plains, Yonkers, Tarrytown, Ossining, and Peekskill are examples. New bus links, even ferry-rail links, further help to bring additional passengers to the rails at 25 county MTA Metro-North stations.

Changes for the better at Croton's West Yard took place in 1996. Profitable Conrail was sold to CSX and Norfolk-Southern Railroads, and in this image, a new GE P32 diesel is being delivered to Metro-North, almost concluding an era of seeking an adequate locomotive supplier for its unique dual-mode electric/diesel needs. The older, now high-maintenance but venerable FL-9 diesel was phased out through 2000 when 20 GE P-32 dual-mode electric/diesel locomotives replaced them. Amtrak's *Lakeshore Limited* from Chicago is at right. (Author's collection.)

At left is a New York–Stamford local arriving at Rye, made up of Kawasaki M-8 equipment. Four hundred M-8s were built in Nebraska and are some of Metro-North's newest equipment. Metro-North and prior operators experienced surges of ridership since the 1960s, caused by county population growth. This at times caused sudden traffic growth, sometimes precipitating an over-crowding problem. This demographic dynamism is sometimes still an issue that can be hard to control. The New Haven Line has come to be the county's busiest when adding out of county traffic and Amtrak trains, such as the one seen here. (Author's collection.)

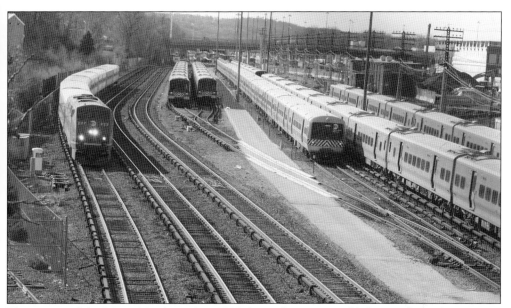

This image of the Metro-North yard in 2015 shows the century-old shop under replacement at right. The yard shows weekend storage of four long consists of Bombardier M-7 MU commuter cars built in 2007 surrounding eighteen 1984 Budd M-3 cars at center. At left, a Poughkeepsie-bound train with now commonplace P-32 motive power leaves Croton-Harmon over a 1990s-modified alignment for the new yard at right. Planning is underway for the next generation of locomotives to eventually replace the P-32s. (Author's collection.)

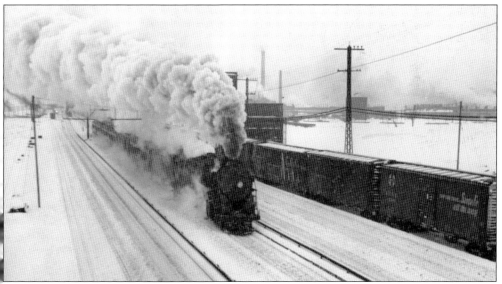

This image of the same location as above in the 1940s shows another train serving many of the same stops. Trains manage snow well, unless it is a blizzard, of course. At right is likely an eastbound perishable train to New York on track 8, an adjacent running/short-term storage track away from mainline traffic yet near for a return to the "main" after steam power is swapped with electric power to New York. Note the 4-6-4 Hudson-type leading, indicative that diesel had taken over premier assignment and now focused on commuter work. (Courtesy of the New York Central Historical Society.)

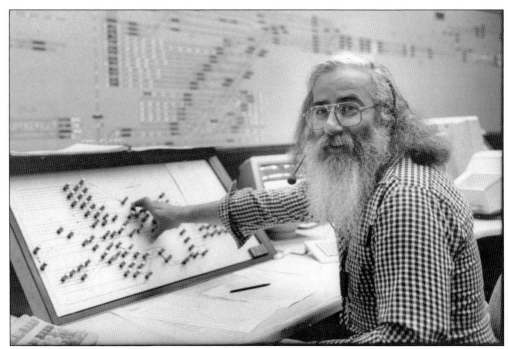

Localized routing duties of towers centralized in the 1990s. Alan Gruber, now a rail traffic controller, was initially a telegrapher-operator in the older towers beginning in 1971; he is seen here using a pre-computer toggle switch. Behind him is a board that shows the narrowing GCT throat and some of the railroad north toward Westchester. This layout, once considered state-of-the-art, has since been replaced. MTA Metro-North runs 800 weekday trains, nearing 300,000 daily passengers yearly, and has an approximate fare recovery of 75 percent of operating expenses. (Photograph by Frank English; courtesy of Alan Gruber.)

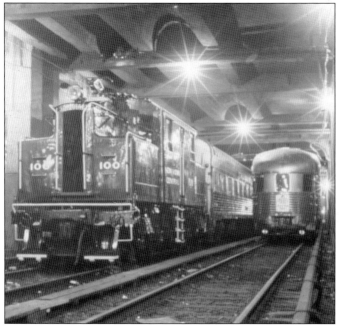

Following decades of bad press, Amtrak and Metro-North enjoy an improved perception in concert with service improvements. MNR also became a desirable movie location. Shown is New York Central's museum piece S-2 electric motor, used in the movie *The House on Carol Street* in 1988. Filming over this territory goes back generations. Some films shot here include *Twentieth Century, North by Northwest, Borgia Stick, The Out of Towners, Ruben Ruben, Falling in Love, Unfaithful, Prince of Tides,* and *Girl on a Train*; there is not enough room to include them all. (Author's collection.)

In 1991, Amtrak began service to Pennsylvania Station, vacating GCT. This also involved reopening the original Hudson River Railroad line south to 35th Street. The inaugural VIP train made a stop in Yonkers. US senator Al D'Amato was seated in the cab's fireman's seat, and Asst. Supt. Dennis Healy, in the hard hat, supervised. The 1976 turbo-train built under French license by Rohr Corporation was still a snazzy enough train to do these honors. The turbos' uniqueness and unusual construction sent them to storage and retirement by 2004. Two sets of turbos remain in storage as of this writing. (Photograph by Kent Patterson, courtesy of the Rail Passengers Association.)

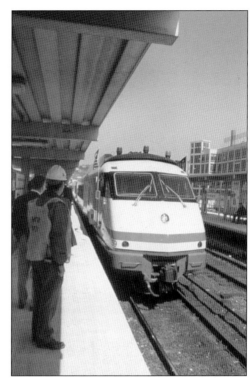

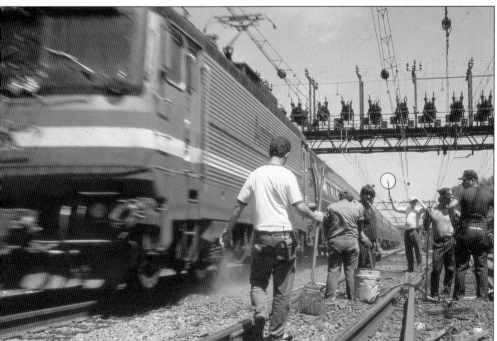

The county's busiest line is also the most complicated. The New Haven Line between Harrison and Rye, seen in 1985 before safety vests were common, also hosts Amtrak's Northeast Corridor in addition to Metro-North's traffic and some through freight. (Photograph by Kent Patterson, courtesy of the Rail Passengers Association.)

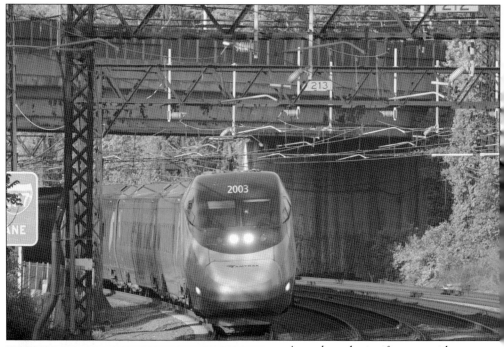

Amtrak made significant corridor investment in its Boston–Washington *Acela*, which has stops in nearby Stamford and Penn Station. It is shown passing Rye in 2018. Rye was briefly the county's Amtrak stop before today's New Rochelle regional Amtrak station. The *Acela* train, under European license, has run since 2000. While the county benefits from rail improvements, just keeping up with the passage of time, such as timely equipment replacement, is a heavy expense. Ideally, a balance of maintaining standards and service enhancements to meet needs will be found. (Authors collection.)

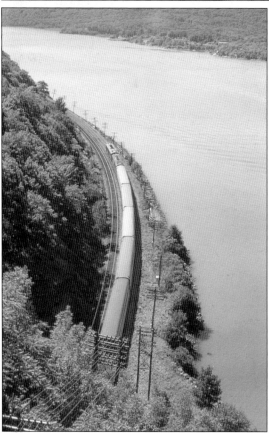

This timeless view from the Bear Mountain Bridge and Appalachian Trail shows a 30-year-old but still graceful streamliner built by General Motors. The Amtrak train from the upstate likes of Rochester, Utica, Amsterdam, or Rhinecliff made, and continues to make, good time along the Hudson River. Soon, some of these cars would vanish, as Amtrak sent some coaches in better condition to Florida streamliner service. (Photograph by Kent Patterson; courtesy of the Empire State Passengers Association.)

BIBLIOGRAPHY

Arcara, Roger. *Westchester's Forgotten Railway: An Account of the New York, Westchester & Boston Railway Company.* New York, NY: Quadrant Press, 1972.

Bang, Robert A., John E. Frank, George W. Kowanski, and Otto M. Vondrak. *Forgotten Railroads through Westchester County.* Port Chester, NY: 2007.

Ballard, Charles L. *Metropolitan New York's Third Avenue Railway System.* Charleston, SC: Arcadia Publishing, 2005.

Edson, William D., Edward L. May, and H.L. Vail Jr. *Steam Locomotives of the New York Central Lines: NYC & Hudson River Railroad, Boston & Albany.* New York Central System Historical Society, 1997.

Gallo, Daniel R., and Frederick A. Kramer. *The Putnam Division: New York Central's Bygone Route through Westchester County.* New York, NY: Quadrant Press, 1981.

Grogan, Louis V. *The Coming of the New York and Harlem Railroad.* Pawling, NY: self-published, 1989.

Griffin, Ernest Freeland. *Westchester County and Its People: A Record.* New York, NY: Lewis Historical Publishing Co., 1946.

Harwood, Herbert H. Jr. *The New York Westchester & Boston Railway: J.P. Morgan's Magnificent Mistake.* Bloomington, IN: Indiana University Press, 2008.

Lynch, Peter E. *New Haven Railroad.* St. Paul, MN: MBI Publishing Company, 2003.

Staufer, Alvin F. *Steam Power of the New York Central System, Vol. 1: Modern Power, 1915–1955.* Self-published, 1961.

Staufer, Alvin F. and Edward L. May. *New York Central's Later Power, 1910–1968.* Medina, OH: self-published, 1981.

Swanberg, J.W. *New Haven Power, 1838–1968: Steam, Diesel, Electric, MUs, Trolleys, Motor Cars, Buses & Boats.* Medina, OH: A.F. Staufer, 1988.

Schiavone, Joe. *The Old Put: New York Central's Putnam Division.* Peekskill, NY: Merit Printing & Publishing, 2007.

———. *More of The Old Put: New York Central's Putnam Division, Vol. 2.* Peekskill, NY: Merit Printing & Publishing, 2009.

———. *The Last of The Old Put: New York Central's Putnam Division, Vol. 3.* Peekskill, NY: Merit Printing & Publishing, 2011.

DISCOVER THOUSANDS OF LOCAL HISTORY BOOKS
FEATURING MILLIONS OF VINTAGE IMAGES

Arcadia Publishing, the leading local history publisher in the United States, is committed to making history accessible and meaningful through publishing books that celebrate and preserve the heritage of America's people and places.

Find more books like this at
www.arcadiapublishing.com

Search for your hometown history, your old stomping grounds, and even your favorite sports team.

Consistent with our mission to preserve history on a local level, this book was printed in South Carolina on American-made paper and manufactured entirely in the United States. Products carrying the accredited Forest Stewardship Council (FSC) label are printed on 100 percent FSC-certified paper.